WORD UP!

Life Empowering Messages

BISHOP GREGORY TUCKER

Copyright © 2015 Bishop Gregory Tucker.

All rights reserved. No part of this book may be used or reproduced by any means, graphic, electronic, or mechanical, including photocopying, recording, taping or by any information storage retrieval system without the written permission of the author except in the case of brief quotations embodied in critical articles and reviews.

WestBow Press books may be ordered through booksellers or by contacting:

WestBow Press
A Division of Thomas Nelson & Zondervan
1663 Liberty Drive
Bloomington, IN 47403
www.westbowpress.com
1 (866) 928-1240

Because of the dynamic nature of the Internet, any web addresses or links contained in this book may have changed since publication and may no longer be valid. The views expressed in this work are solely those of the author and do not necessarily reflect the views of the publisher, and the publisher hereby disclaims any responsibility for them.

Any people depicted in stock imagery provided by Thinkstock are models, and such images are being used for illustrative purposes only.
Certain stock imagery © Thinkstock.

ISBN: 978-1-5127-0628-4 (sc)
ISBN: 978-1-5127-0627-7 (e)

Library of Congress Control Number: 2015912220

Print information available on the last page.

WestBow Press rev. date: 12/03/2015

CONTENTS

Acknowledgments .. vii

Chapter 1	Now Word!.. 1	
Chapter 2	Don't Count Me Out... 5	
Chapter 3	Don't Forget God! ... 8	
Chapter 4	From Once Upon a Time... 12	
Chapter 5	Armed and Dangerous"... 16	
Chapter 6	How Long? ... 20	
Chapter 7	Is it in you to Live above the Influence................... 23	
Chapter 8	"I know it is the Blood".. 27	
Chapter 9	"Something Good is coming out this" 30	
Chapter 10	Jesus is a Rock... 33	
Chapter 11	Out Into the Deep .. 35	
Chapter 12	Let Your Light Shine... 37	
Chapter 13	Kill are be killed .. 39	
Chapter 14	Living in the 4th Dimension................................... 42	
Chapter 15	God is looking for Men of Faith 45	
Chapter 16	Access Granted ... 48	
Chapter 17	All in one and one in All...51	
Chapter 18	My Hope is in God... 55	
Chapter 19	"Bruised but not broken, Dimmed but not out" 57	
Chapter 20	Obeying God Instructions.......................................61	
Chapter 21	Five Principles that bring Angels alongside us to help us: 62	
Chapter 22	Promise Anointing.. 64	
Chapter 23	"Have You Receive Since You Believed" 68	
Chapter 24	(Second Adam) ... 70	

Chapter 25	Seven Wonders of Heaven	73
Chapter 26	Staying behind or Moving Forward"	76
Chapter 27	"The Church that refused to Complain"	80
Chapter 28	Learning The Easy Way To Pray	82
Chapter 29	The Law of Sowing and Reaping	90
Chapter 30	"The Promise Keeper"/ "He Never Failed me Yet"	92
Chapter 31	John 14:1-6 - The Way Truth and the Life	96
Chapter 32	To Die Is Gain	99
Chapter 33	"The Power of Friendship"	101
Chapter 34	Building Strong Saints	104
Chapter 35	Trying of your Faith	107
Chapter 36	"What you need God Got It"	110
Chapter 37	When Men Step Up To The Plate	112

Reference Notes ... 119

ACKNOWLEDGMENTS

I want to thank my Lord and Savior Jesus Christ for anointing me to Preach and Teach the Word of God since 1974. I could have never done this on my own. It is through God grace and mercy that this book has been written.

I thank my wife Virginia for over 39 years a woman of wisdom for her encouragement and support always pushing me to write my messages down before I speak. Thanks to my children Craig, Anjulet, Dailou, & Gregory J that taught me patients, endurance and wisdom through the trial and error of parenting.

Lastly I want to thank my One Way Church of Christ family who have stood with me in our ministry effort, and have always expressed their love and support.

CHAPTER 1

Now Word!

Deuteronomy 1:6 - Horeb was the mountain range in which Mt. Sinai was located. The word Horeb means desolate place. The Israelites had been camped at Horeb for about a year. This was a call and charge of God to break camp leave Sinai march and lay claim to the promised land.

Deuteronomy 2:3 - And the Lord spake unto me, saying, **Ye have compassed this mountain long enough: turn you northward.** Remember the terrible sins the kept the first generation of Israelites out of the promised land. **Fear, Unbelief, grumbling, and rebellion** (1:18-39)

Sometimes we get stuck on a job that has no future.
Stuck in a relationship with someone who means you no good. When I get a divorce than we are going to get married. He told you that 5 years ago.
Stuck in a business with a partner who has no vision.

The promised land would include most of modern Palestine and Syria. The promised land was promised to Abraham and all his descendants by covenant by a contract that was guaranteed by God Himself.

Number 23:19 - God is not a man, that he should lie; neither the son of man, that he should repent: hath he said, and shall he not do it? or hath he spoken, and shall he not make it good?

(Now is the Time to go where God tell you to)

Gen 12:1-3 Now the Lord had said unto Abram, **Get thee out of thy country, and from thy kindred,** and from thy father's house, unto a land that I will shew thee: 2 And I will make of thee a great nation, and I will bless thee, and make thy name great; and thou shalt be a blessing: 3 And I will bless them that bless thee, and curse him that curseth thee: and in thee shall all families of the earth be blessed.

Places Matter especially if God tells you to go to a certain place.

In 1 Kings 17:9 - Arise, **get thee to Zarephath**, which belongeth to Zidon, and dwell there: behold, I have commanded a widow woman there to sustain thee.

(Jesus and the Disciples eats the passover)Mark 14:15- 15 And he will shew you a **large upper room furnished and prepared:** there make ready for us.

The Holy Spirit birthed the early Church - Acts 1:4 - And, being assembled together with them, commanded them that they should not **depart from Jerusalem**, but wait for the promise of the Father, which, saith he, ye have heard of me. 5 For John truly baptized with water; but ye shall be baptized with the Holy Ghost not many days hence.

2 Kings 5:10 - 10 And Elisha sent a messenger unto him, saying, **Go and wash in Jordan** seven times, and thy flesh shall come again to thee, and thou shalt be clean.

You will succeed somewhere. You will not succeed everywhere.

A sinner who understands **decision making** will succeed quicker then any christian who is **waiting for a miracle.**

The bible is a book about decisions what you'll willing to focus on, what you are willing to overcome, the offense you are willing to forgive, focus of your time your energy, who opinions you trust.

Key Point: **Never stay where God has not assigned you!** If you do your weakness will flourish your strength will die. A fish out of water will die

but once it is put back into the water there movement becomes electrifying and their true potential is seen.

When God is doing a New Thing in you, You have to move to a higher level of thinking.

Dream Big.

Solomon in his backslidden stage said in Ecclesiastes 1:9 there is nothing new under the sun. But in Lamentations 3:22-23 - 22 It is of the Lord'S mercies that we are not consumed, because his compassions fail not. 23 They are **new every morning**: great is thy faithfulness.

Isaiah 43:19 - Behold, I will do a **new thing**; now it shall spring forth; shall ye not know it.

(5 Stages to a Dream)
I **thought it** Stage
I c**aught it** Stage
I **Bought it** Stage
I **Sought it** Stage
I **Got it** Stage

The purpose of Your Dream is to keep you moving, moving from your past, your yesterday. Movement is the proof of life and change.

It important you have a **dream or goal** something you want to accomplish. God gave you life but you decide what you experience with it.

Genesis 37:19 - And they said one to another behold this dreamer cometh. 23 - And it came to pass when Joseph was come unto his brethren, that they script Joseph out of his coat, his coat of many colors that was on him.
THERE IS SOMETHING YOU ARE WEARING THAT IS AGITATING AN ENEMY.
SOME CALL IT AN ANOINTING, A GRACE.
IT REMINDED THEM WHO THERE DADDY LIKED!

Bishop Gregory Tucker

GOD IS PUT THE ANOINTING ON YOU TO LET YOU KNOW YOU ARE NOT LIKE THE OTHERS.

Obeying the voice of the Spirit by Keeping and intimate relationship with the invisible God.

What Peter could not become in 3 and one half years walking next to Jesus. He became in a Day when the Holy Spirit entered.
Holy Spirit is not wind but it moves like wind
Holy Spirit is not fire, it purifies like fire.
Holy Spirit is to us like Jesus was the the 12 disciples
a. Find a place in your home to spend time with God b. Learn to sing to the Holy Spirit C. Listen for his voice of wisdom - Isaiah 11:1 Call the spirit of wisdom

Eph 1:17 - 17 That the God of our Lord Jesus Christ, the Father of glory, may give unto you the **spirit of wisdom and revelation in the knowledge of him.**

CHAPTER 2

Don't Count Me Out

Amos was a shepherd and fig grower from the Southern Kingdom (Judah), but he prophesied to the Northern Kingdom (Israel). Israel was politically at the height of its power with a prosperous economy, but the nation was spiritually corrupt, idols were worshiped throughout the land, and especially at Bethel, which was supposed to be the nation's religious center. Like Hosea, Amos was sent by God to denounce this social and religious corruption. About 30 or 40 years after Amos prophesied, Assyria destroyed the capital city, Samaria and conquered the nation (722 B.C.)

Purpose: To pronounce God's judgment upon Israel, the Northern Kingdom, for their complacency, idolatry, and oppression of the poor.

To Whom Written: Israel, the Northern Kingdom, and God's people everywhere.

Setting: The wealthy people of Israel were enjoying peace and prosperity. They are quite complacent and were oppressing the poor, even selling them into slavery. Soon however Israel would be conquered by Assyria, and the rich would themselves be made slaves.

Amos name mean burden or burden bearer. He carried the heavy burden of God's message to Israel.

Visions are born out of those who carry a burden for God people. God gave Amos a vision of what was about to happen to the nation of Israel.

God condemns all the nations who have sinned against him and harmed his people. Tyre, Edom, Ammon, and Moab. Amos homeland is included in God punishing His people. But after all the chapters on judgement the book concludes with a message of hope. God will restore his people and make them great again.

In Amos 3:12 - Even in the midst of what Israel was going through, the shepherd saw in the sheep something redeemable. He took out of the mouth of the lion two legs, a piece of an ear. This lets me to know that a true shepherd of God never give up on God's people even though it seems like the devil has destroyed them. The shepherd took from the lion two legs, and a piece of ear. This should remind us it's not what you have lost it what you have left. As long as you have and ear to hear and a leg to stand on you will be alright.

Rev 3:22 - He that hath an ear, let him hear what the Spirit saith to the churches.

Lion represent Satan - 1 Peter 5:8 - Be sober, be watchful: your adversary the devil, as a roaring lion, walketh about, seeking whom he may devour, 9 whom withstand stedfast in your faith, knowing that the same sufferings are accomplished in your brethren who are in the world.

(Shepherd on earth)
Sheep represent the people of God - Jeremiah 3:15 - and I will give you shepherds according to my heart, who shall feed you with knowledge and understanding.
(Shepherd in Heaven) Psalm 23 - Jehovah is my shepherd; I shall not want.
2 He maketh me to lie down in green pastures; He leadeth me beside still waters.
3 He restoreth my soul: He guideth me in the paths of righteousness for his name's sake.
4 Yea, thou I walk through the valley of the shadow of death, I will fear no evil; for thou art with me; Thy rod and thy staff, they comfort me.
5 Thou preparest a table before me in the presence of mine enemies: Thou hast anointed my head with oil; My cup runneth over.

6 Surely goodness and lovingkindness shall follow me all the days of my life; And I shall dwell in the house of Jehovah for ever.

John 10:11 I am the good shepherd: the good shepherd layeth down his life for the sheep. 12 He that is a hireling, and not a shepherd, whose own the sheep are not, beholdeth the wolf coming, and leaveth the sheep, and fleeth, and the wolf snatcheth them, and scattereth them: 13 he fleeth because he is a hireling, and careth not for the sheep. 14

1 Corinthians 2:9 - But as it is written, Eye hath not seen, nor ear heard, neither have **entered into** the **heart** of **man**, the things which God hath prepared for them that love him.

I know my husband left me with these kids to take care of:

I just receive my last unemployment check:

<u>That problem that I had I just couldn't seem to solve,</u> I tried and I tried kept getting deeper involved And I stopped worrying about it I turned it over to the Lord and He worked it out.

1 Peter 2:9 - But ye are a elect race, a royal priesthood, a holy nation, a people for God's own possession, that ye may show forth the excellencies of him who called you out of darkness into his marvellous light: 10 who in time past were no people, but now are the people of God: who had not obtained mercy, but now have obtained mercy.

I might be down for the count but don't count me out!
Will Smith known as Chris Gardener in the movie "The Pursuit of Happiness never gave up on his dream. Nelson Mandela after spending twenty seven year in prison later came to be the President of South Africa. Don't let anyone destroy your dream.
Dream Big Aim High.

CHAPTER 3

Don't Forget God!

Have you ever known someone who is always late for everything? They are always in a rush just to catch up because they are always late. At times this kind of habit can be costly, they miss out on important things or information because of a late arrival. How much better to be on time and start early, this is precisely the idea behind this passage.

A man who came rushing up to a Ferry he needed to catch to get across a lake, He arrived breathless after running full steam to get there, but the gateman shut the door in his face, he just missed the Boat! A bystander remarked to Him, I Guess you didn't run fast enough, the disappointed man answered, I ran fast enough but I didn't start on time. To accomplish the most for God in a lifetime you must start early.

Ecclesiastes 12:1 - Remember now your creator in the days of your youth, while the evil days come out, nor the years draw near, when you shall say, I have no pleasure in them.

New living Translation: Don't let the excitement of youth cause you to forget your Creator. Honor Him in your youth before you grow old and say, "Life is not pleasant anymore."

Remember (God before old age comes-the days of darkness and trouble)

We are to pay attention to God to consider Him with the intention of obeying. Solomon admonishes us to keep our minds on God, to allow Him

to influence and control our decisions and conduct. We should remember that God is continually present in our lives. Once we accept Christ as Savior, the Spirit of God actually lives within our bodies. We need to remember this wonderful truth because it means that we always have God's presence to guide and help us through the trials of life..

"What? know ye not that your body is the temple of the Holy Ghost which is in you, which ye have of God, and ye are not your own? For ye are bought with a price: therefore glorify God in your body, and in your spirit, which are God's" (1 Co.6:19-20)

Here is Solomon's admonition: live with the awareness of God throughout your younger years, while you still have the desire and energy to enjoy the things that this life has to offer. The days of advanced age are inevitably coming; therefore, there will come a time when you will no longer be able to do these things. Notice how Solomon describes the latter years—the so-called "golden years" of life:

1) The latter years will be days of no pleasure (v.1). Is the aged king saying there are no joys whatsoever to be found in the older years of life? No, this is not his meaning at all. Every age and stage of life has its unique joys and delights. Solomon is merely saying this: many of the things we enjoyed in the younger years of life are no longer appealing or pleasurable in old age. Through the passing of years, our desires change just as our bodies and minds change.
2) The latter years will be days of no light or joy, days that grow dark from clouds of problems and the pain of growing old (v.2). This refers to persistent conditions—impairments, afflictions—that do not go away. Focus for a moment on the phrase "the clouds return after the rain." After dark, heavy clouds dump their rains upon the earth, what do they do? They roll on by, and when they have gone, the sun shines again. This is not the case with the storm clouds of old age. They stay...and hover. The rains may cease, but the clouds remain, and it will rain again. In the same way, the senior citizen may find relief from the aches and pains of the body, but it

is only temporary. The aches and pains will return when the pill or treatment wears off.

As a young person, you should learn to faithfully walk with the Lord while you have the energy and strength of youth. A day is coming when your body will age and weaken, and you will not be able to serve God as energetically as you did during your younger years. You will not endure putting in the long hours and participating in so many activities.

1) Before your limbs tremble and you cannot protect your home (v.3a). The keepers of the house are the arms and legs that weaken and tremble with age.
2) Before your body is stooped over (v.3b).
3) Before your teeth start falling out (v.3c).
4) Before your eyesight starts failing (v.3d). The windows refer to the eyes.
5) Before your legs become too weak to walk outside (v.4a). Some older people are housebound or in nursing facilities due to weakness or due to the onset of infirmities that hinder them from going out the doors and into the streets.
6) Before your hearing begins to fade (v.4b).
7) Before your sleep is halted by birds (v.4c). Many older people do not sleep well and are easily awakened by the birds' chirping, but they themselves no longer have the strength to sing.
8) Before your fear of heights and other dangers restricts your actions (v.5a).
9) Before your hair turns as white as an almond blossom (v.5b). The almond tree's snow white blossoms are an excellent picture of the gray or white hair of the elderly.
10) Before your pace is as slow as a grasshopper at season's end (v.5c). As the grasshopper nears the end of its life, it no longer hops but drags itself along the ground.
11) Before your sexual desire is gone (v.5d).

Do not sow seeds of sin in your youth that you will painfully reap in the harvest time of old age. Do not forgot God and bring His judgment upon yourself.

Remember, Solomon is teaching us from his own mistakes. He had forgotten God and broken God's law by marrying women who were unbelievers and who worshipped idols. He then compounded the sin by blaspheming God, actually worshipping his wives' idols right along with them. Solomon had indulged his young flesh in the carnal pleasures of wine, women, and song—and he was now living to regret it.

His latter years were filled with remorse because he did not remember his Creator in the days of his youth.

"I beseech you therefore, brethren, by the mercies of God, that ye present your bodies a living sacrifice, holy, acceptable unto God, which is your reasonable service. And be not conformed to this world: but be ye transformed by the renewing of your mind, that ye may prove what is that good, and acceptable, and perfect, will of God" (Ro.12:1-2).

CHAPTER 4

From Once Upon a Time

Proverbs 22:28 - Good News Bible - Never move an old property line that your ancestors established.

KJV: Remove not the ancient landmark which thy fathers have set.

Ephesian 5:14-16 - Wherefore he saith awake thou that sleepiest, and arise from the dead and Christ shall give thee light, see then that ye walk circumspectly not as fools but as wise redeeming the time because the days are evil.

Once upon a time in the Church of Our Lord Jesus Christ **Apostle** was known for their anointing and Power to heal the sick and even raise the dead not for their degree and Staus in society.

Once upon a time **Prophets** prophesied with Holy Ghost precision not with spiritual games.

Once upon a time **Evangelist** worked miracles with signs and wonders following.

Once upon a time **Pastors** shepherd their flocks not for filthy lucre sake and not to be rule as Lords over God's inheritance but with love and concern for the flock.

Once upon a time **Teacher** studied the word day and night like the Berean did to make sure they rightly divided the Word of God correctly.

Once upon a time soul was added to the church daily not every now and then.

Once upon a Saints came to the house of the Lord to give God the Praise not to Praise one another.

Christian acted as Christian. There was no such thing as one a week Christianity but everyday with Jesus was sweeter then the day before.

There was no such thing as hanging out on Saturday night in the Clubs and Sport Bars then on Sunday singing the Lord Songs.

Saints was Saints and sinners was sinners. You could tell who was born again from those who was not by the way they talked, acted and dressed. Now it hard to tell Who's Who.

Once upon a time saints would pray for hours and fast for days pleading for the power of God to be manifested. But now we pray for 45 minutes and fast for one day and look for miracles to be performed in our services.

I believe in this last hour God is raising up an army of believers who is believing God and praying for the "Old Time Power" "Old Time Love"

Old Time Character.

Old Time Power - When people got saved their lives changed, the power of God cause them to give up coming, drinking, lying, anger, wrath, and such like, the works of the flesh was under control.

Old Time Love - Their love of God overpowered lusts and passions of the flesh.

If you do find someone who operates in the gifts of the spirit they are arrogant, prideful and untouchable.

Many of us in the body of Christ had potential but like the character every child of God should have.

In Genesis 49:3-4 - When Jacob the father of the twelve tribes of Israel called forth his sons and prophesied over them. Beginning with Reuben he said "You are my firstborn, my might the first sign of my strength, excelling in honor, excelling in power.

God concerns the first born child to lead the way for the other sibling to follow. Jacob tell Reuben what he could be if he just would do right.

Look at your neighbor and say "If You Live Right Heaven belongs to You"

God called Israel the Apple of His Eyes while they were murmuring and complaining
God called Gideon a might man of valor even when the was hiding
God called Moses to lead the Children of Israel out of Egypt while he was still attending Jethro sheep.
God called his children more than a conqueror even before the victory is won.

But instead of Reuben living out the fulfillment of the prophecy he chose to do his own thing.

And that what wrong with the Modern Day Pentecostal Church many of us want to do our own thing. It your thing do what you want you want to do I can tell you who to sock it to.

Doing own thing has cost many in the Body of Christ to backslide. Singing in the choir but backslidden, preaching the word but backslidden, taking communion but backslidden.

Great expectation had been formed of Reuben but he refused to answer the call. He had a double portion of the birthright and was well positioned to receive all the privileges and rights associated with the title.

Live a clean life before God - Roman 12:1-2 - I beseech you therefore brethren, by the mercies of God, that ye present your bodies a living sacrifice holy acceptable unto God, which is your reasonable service. And be not conformed to this world but be ye transformed by the renewing of your mind, that ye may prove what is that good, and acceptable and perfect Will of God.

Now it it time: To Push - Pray until something happen
Now it it time: To Pull - Pray until lust Leaves
Now it is Time: Press your way! **Get some violence faith** - Matthew 11:12 - And from the days of John the Baptist until now the Kingdom of of heaven suffers violence and the violent take it by force.
Now it is Time: **Stretch your Faith!** - Matthew 9:21 - For she said within herself, If I may but touch his garment I shall be whole.
Now it is Time: To spent some Time with God - We're always in a hurry, Excuse me I've gotta run. We're the only country in the world that has a mountain named "Rushmore".

CHAPTER 5

Armed and Dangerous"

Ezekiel 22:30 - And I sought for a man among them, that should make up the hedge, and stand in the gap before me for the land, that I should not destroy it: but I found none.

Ezekiel was the son of a priest. He was deported to Babylon in 597b.c. with King Jehoiachin during Israel captivity in Babylon. His ministry was twofold, to remind the exiles of their sins and to encourage them concerning God's future blessings.
Isaiah speaks of God's salvation
Jeremiah speaks of God's judgement
Daniel speaks of God's Kingdom
Ezekiel speaks of God's Glory

In this chapter God contrasts the poor leader with Godly leaders. The poor leader oppresses and destroys his or her followers, while the Godly leaders stands in the gap on behalf of the land and the people.

Ten traits of the leader God Affirms:

- Consecrated Man or Woman sets themselves apart and remain committed to their call
- Discipline: They do what is right even when it is difficult.
- Servanthood: They model a selfless life, lived for the benefit of others.
- Vision: they see what God sees and live off the power of potential

- Compassion: Love for their cause
- Trustworthiness: They keep their word regardless of what others do.
- Decisiveness: They make good decisions in a timely manner.
- Wisdom: They think like God thinks and avoid impetuous moves
- Courage: They take risks for what is right
- Passion: They demonstrate enthusiasm for their divine calling

I find theses traits in men and women of God who has given themselves over to God:

As an apostle they pioneer and establish new works and new leaders.
As a Prophet they speaks forth God's Word to inspire, correct, and motivate.
As an Evangelist they shares Christ with the unchurched and trains others to do so.
As a Pastor they warn, care, and protect the people of God.
As a Teacher they explains God Word so that even a little child or a fool can understand it.

Ezekiel 1:1-5 - The hand of the Lord was upon me, and carried me out in the spirit of the Lord, and set me down in the midst of the valley which was full of bones, 2 And caused me to pass by them round about: and, behold, there were very many in the open valley; and, lo, they were very dry. 3 And he said unto me, Son of man, can these bones live? And I answered, O Lord God, thou knowest. 4 Again he said unto me, Prophesy upon these bones, and say unto them, O ye dry bones, hear the word of the Lord.

Dry bones of our day represent the deterioration in our homes and churches because of the neglect of God's truth.
When preacher are condoning and marrying same sex couples
Dry bones is when pornography went from illegal, to age appropriate to free web access.
Dry bones is when dating couples went from kissing to shacking up to multiple partners and free sex.
In generation past we looked up to men like Dr. Edward H. Boyce, my father in the Thomas P. Bulter, Nelson Mandela but today our young men

are looking up to Pee Diddy, Jay Z, Nate Dogg, Dr. Dre, Eminem, Q-Tip Slick Rick.

verse: 7 So I prophesied as I was commanded: and as I prophesied, there was a noise, and behold a shaking, and the bones came together, bone to his bone.

10 See, I have this day set thee over the nations and over the kingdoms, to root out, and to pull down, and to destroy, and to throw down, to build, and to plant

Because your are armed and dangerousness

- Offer healing to the hurting
- Assurance to the accused
- Compassion to the incarcerated
- Direction to the misguided

Weapons that make you armed and dangerous Are:

Name of Jesus at the name of Jesus every knee shall bow and every tongue confess that Jesus is Lord to the Glory of God.
(Song In The Name of Jesus) we have the victory satan will have to flee

Blood of Jesus - Rev 12:And there was war in heaven: Michael and his angels fought against the dragon; and the dragon fought and his angels, 8 And prevailed not; neither was their place found any more in heaven. 9 And the great dragon was cast out, that old serpent, called the Devil, and Satan, which deceiveth the whole world: he was cast out into the earth, and his angels were cast out with him.

11 And they overcame him by the blood of the Lamb, and by the word of their testimony; and they loved not their lives unto the death

Word of God - Isaiah 55:11 -It is the same with my word. I send it out, and it always produces fruit. It will accomplish all I want it to, and it will prosper everywhere I send it.

Power of God - Luke 10:19 - 19 Behold, I give unto you power to tread on serpents and scorpions, and over all the power of the enemy: and nothing shall by any means hurt you

CHAPTER 6

How Long?

Mark 5:25-34

Many of us have the impression that once we get saved all our problems (issues) will disappear but we must have skipped bible study when the Pastor was teaching on the Fruit of the Spirit. Galatians 5:22 - But the fruit of the Spirit is love, joy peace, long-suffering gentleness goodness faith. Somethings in life you will have to put up with until the time is right to be delivered.

This woman was separated and alone, day after day, month after month, year after year, with no physical contact from another human being. Her very presence caused some who knew her condition to recoil in order to avoid their own contamination.

For twelve years, she was bleeding from her body, leaving her weak and unclean in the eyes of her family and community. Along with her issue came other problems Frustration, A broken heart, confusion, and embarrassment.

She could have no contact with her husband or children. Anything she touched or sat on was unclean. She could not enter into the temple. She was shunned, And now she was broke.

Some of us today have issues.

- A. Bankruptcy - you can fix it with the bank, but you still need healing for the shame the pain and the disappointment you feel.
- B. Divorce - you can get a divorce, but you still need healing from the pain, heartache, the lowliness.
- C. A parent with Azheimer's /Son or daughter hooked on drugs.
- D. You may be facing the betrayal by a friend or loved one, You can patch things up but you still need healing from the hurt, distrust and anger.
- E. You can move to a different town, get a different job. You can remarry, but you're still going to need healing from your issues.

After twelve of years she came to the conclusion that enough is enough. 'Verse 28 For she said, If I may touch but his clothes, I shall be whole. She knew the history behind the hem of his garment. When David crept up on Saul while he slept, he cut off the hem of his skirt and thus robbed him of his status symbol. The fringe of his robe identified him as king. This woman knew what she was doing she reached for the fringes or tassels on Jesus prayer shawl, they identified his authority. The corner of the prayer shawl are often called wings. Malachi said, but unto you that fear my name shall the son of righteousness arise with healing in his wings. She knew that if he were the Messiah there would be healing in his wings.

I founded out that God doesn't have respect of person but he does have respect of faith.

The deciding factor in her healing was that they reached out and worshipped him or touched him in some fashion. god responds to worship and touch.

Faith is the finger whereby we touch God. When faith walks, devils hide, sickness flees, and miracles happen.

Faith cannot be stopped, it laughs at impossibilities, walks through the walls of difficulty, leaves a trial of miracles wherever it goes and it counts it done before the evidence is seen.

Bishop Gregory Tucker

Joshua 18:2-3 - And there remained among the children of Israel seven tribes, which had not yet received their inheritance. And Joshua said unto the children of Israel, How Long are ye slack to go to possess the land, which the Lord God of your fathers hath given you?

Seven of the tribes were standing around with their hands in their pockets. They said to Joshua, What about this land? What are you going to give us? Joshua told them, You have been given a certain area. Go and possess your land. How long are you going to wait.

Sam Cooke old song - It been a long time coming but a change gotta come Sam took what was going on in his life (dealing with racism and the death of his son which he had suicidal thoughts over) and make song out of his experience.

There's been times I thought I couldn't last alone but now I think am able to carry on.

CHAPTER 7

Is it in you to Live above the Influence

1 John 4:4 - Ye are of God, little children, and have overcome them: because greater is he that is in you, than he that is in the world.

Purpose: 1 John was written to reassure Christians in their faith and to counter false teachings. The letter is untitled and was written to no particular church. It was sent as a pastoral letter to several Gentile congregations. It was also written to all believers everywhere.

Setting: John was an older man and perhaps the only surviving apostle at this time. He had not yet been banished to the island of Patmos where he would live in exile.

As the elder statesman in the church, he wrote this letter to his little children. He presents Christ as **Light, Love** and **Life**.

False teachers had entered the church, denying the incarnation of Christ. John wrote to correct their errors.

Influence - The power of a person or things to affect others.
World - Cosmos - Whole universe -

Paul also calls satan the God of the World. The God of this world system. 2 Cor 4:4 - 4 In whom the god of this world hath blinded the minds of them which believe not, lest the light of the glorious gospel of Christ, who is the image of God, should shine unto them.

John shows use the difference between(light and darkness) (Truth and Error) (God and Satan) (Life and death) (Love and Hate) (Good and Evil)

The kingdom of Heaven represent God's way of doing things while the kingdom of satan represent satan way of doing things.

1 Corinthians 15:34 - 33 Be not deceived: **evil communications corrupt good manners.** 34 Awake to righteousness, and sin not; for some have not the knowledge of God: I speak this to your shame.

Satan used the **serpent** to **influence** and **deceived** Eve to disobey God's command.

Notice in 2 Cor 11:3 - it says But I fear less somehow as the serpent deceived Eve by his craftiness so your minds may be corrupted from the simplicity that is in Christ.

Satan **influenced Cain** to bring a sacrifice of his own choosing. The spirit of Jealousy come before murder. (Jealousy is cruel as the grave) Song of Solomon 8:6

The deception and influences of Satan had taken over the whole world.
Gen 6:5 -

And God saw that the wickedness of man was great in the earth, and that every imagination of the thoughts of his heart was only evil continually. 6 And it repented the Lord that he had made man on the earth, and it grieved him at his heart.

Matthew 24:37 - But as the days of Noe were, so shall also the coming of the Son of man be. 38 For as in the days that were before the flood they were **eating** and **drinking**, marrying and giving in marriage, until the day that Noe entered into the ark,

Satan influence Nimrod to build a tower so that if another flood came their lives would be saved and they would be able to continue to live in a sinful state.

Positive Influences

Kids with supportive parents have higher levels of self-esteem, higher grades in school, and greater academic success, as well as lower levels of withdrawal, depression, fighting, drinking, smoking and engaging in other risky behaviors.

Acts 9:31 - Then had the churches rest throughout all Judaea and Galilee and Samaria, and were edified; and **walking in the fear of the Lord**, and in the **comfort of the Holy Ghost, were multiplied.**

To live above the influence of the world we must have two things.

The **fear of the Lord** and the **comfort of the Holy Spirit.**

Roman 7:18 - 18 For I know that in me (that is, in my flesh,) dwelleth no good thing.

Promise are given to those who fear the Lord:

Psalm 34:7 - The **angel of the Lord encamps a**ll around those who fear Him, and delivers them.

(Supplies His Provision)
Psalm 34:9 - Oh, fear the Lord, you His saints! There is **no want to those who fear Him.**

(Contains great Mercy)
Psalm 103:11 - For as the heavens are high above the earth, **so great is His mercy** toward those who fear Him.

(Provide assurance of food)
Psalm 111:5 - He has given food to those who fear Him; He will ever be mindful of His covenant.

(Promises Protection)
You who fear the Lord, trust in the Lord; he is their help and their shield.

(Fulfills our desires and delivers us from harm)
He will fulfill the desire to those who fear Him; He also will hear their cry and save them.

There is a difference between being scared of God and the fear of the Lord.

The Bible says we've not been given a spirit of fear; not to be scared of God.

The man who is scared has something to hide. Adam hid from the presence of the Lord. The man who fears God has nothing to hide.

It is by the fear of the Lord that we stay away from sin.

One of the works of the Holy Spirit is to **comfort the believer**. The word conformer means once to run to our side and pick us up. This is what Jesus had done while He was on the earth. 1 John 2:1 - My little children, these things write I unto you, that ye sin not. And if any man sin, we have an advocate is the same word as comforter.

CHAPTER 8

"I know it is the Blood"

Lev 17:11/1 Peter 1:18-20
- Blood sustains life. It is the life fluid of the body.
- It takes nourishment to the body and carries away waste.
- Sixty thousand miles of blood vessels link every living cell in the body.
- The heart pumps five quarts of blood through the body every twenty-three seconds

The Bible treats blood as a sacred fluid symbolic of life. The word blood is used more than four hundred times. Blood circulates through every page and verse of God's Word. From Genesis to Revelation we see a stream of blood that imparts the very life of God.

In the Old Testament The Lord passed over each home protected by the blood. Exodus 12:13 - And the blood shall be to you for a token upon the houses were you are: and when I see the blood, i will pass over you, and the plague shall not be upon you to destroy you, when I smite the land of Egypt.

The Blood of Jesus
B - Makes me **Bold**
L - Satan have to **leave** when he sees the Blood
O - **Overcoming** Power
O – **Omnipresence** – He is presence wherever I go
D - Deliverance is yours when the Blood is applied

- No salvation in any form without the application of the Blood
- All the vessels of the tabernacle were made holy by sprinkling of blood
- The priests were counted worthy for service after the application of blood on his garments
- Blood applied upon the tip of the ear, thumb of the hand, toe of the foot of the Priest.

Exodus 29:19-21

Tip of the Right ear for Hearing
So that the Priest could hear directly from God without distraction from outside forces

Right Thumb of the Hand for Service Priest would touch the lives of all people with the message of the Gospel

Right Toe of the Priest
Carry the Gospel message to a dying world Great Commission

Food for thought

- There is no cleansing agent as powerful as the Blood!
- It will cleanse our past
- Will cleanse the Present
- And it still offers Hope for the future

Isaiah 1:18 - Come now, and let us reason together, saith the Lord though your sins be as scarlet, they shall be as white as snow, though they be red like crimson, they shall be as wool.

Sin stops the blood of Jesus from flowing in our lives. A blood transfusion takes the blood from a healthy individual and puts it into the veins of an unhealthy suffering person. Through repentance and water baptism in Jesus name Christ's blood cleanses away sin (waste).

The blood of Jesus is so powerful because our Redeemer did not partake of Adams's blood. He did not have a drop of Adam's blood in His veins. An unborn baby's blood is not taken from the mother, but from the father, Jesus was conceived of the Holy Ghost.

"But now in Christ Jesus ye who sometimes were far off are made nigh by the blood of Christ" (Ephesians 2:13).

Jesus made the sacrifice once and for all.

"For this is my blood of the new testament, which is shed for many for the remission of sins" (Matthew 26:28)

Jesus ascended into heaven and made atonement for us. In the Tabernacle the priest sprinkled blood over and over. There were six pieces of furniture in this portable church. Not one was a chair. The priest could not sit down because his work was never complete. Jesus offered one sacrifice for our sins and then sat down. His work was complete. "It is finished" (John 19:30), He said from the cross.

CHAPTER 9

"Something Good is coming out this"

Roman 8:28

It very hard to see how a crisis caused by hardships, pain and suffering is working for your good. I can see how having a job, being in good health, married to a wonderful spouse, living in a nice home is working for my good.

But when you lose your job, and the doctor just informed you that your X-ray came back positive and now you are in the third stage of cancer. Your marriage is on the rocks and your home going into foreclosure.

Can we still say everything is working for my good. Well my sisters and brothers I didn't say it the Word of God says it and if the Word say it my opinion doesn't matter. God's Word answers the questions to life most puzzling situations. We must not allow the enemy to cause us to be angry and bitter toward God and others because our trial and tribulations. Loving God allows one to see things from God's preservative. Through the eyes of God no matter whats happens to me it all working for my Good.

Isaiah 55:8-9 - For my thoughts are not yours thoughts, neither are your ways my ways saith the Lord. For as the heavens are higher than the earth so are my ways higher than your ways and my thoughts than your thoughts.

When you face trials, tribulation and even a crisis consider these things.

1. God is working everything for my good
2. God is in control of everything - Psalms 103:19 - The Lord has prepared his throne in heaven and his kingdom rules overall.
3. We learn more about ourselves and God when we are faced with afflictions. It was good for me that I was afflicted - Psalms 119:71
4. What painful for you today will be profitable for you tomorrow.

A little piece of wood once complained bitterly because its owner kept whittling away at it, cutting it, and filling it with holes, but the one who was cutting it so remorselessly paid not attention to its complaining. He was making a flute out of that piece of ebony, and he was too wise to desist from doing so, even though the wood complained bitterly. He seemed to say, Little piece of wood, without these holes, and all this cutting you would be a black stick forever-just a useless piece of ebony. What I am doing now may make you think that I am destroying you, but, instead, I will change you into a flute, and your sweet music will charm the souls of men and comfort many a sorrowing heart. My cutting you is the making of you, for only thus can you be a blessing in the world.

5. God is the only one I know that take a bad situation and make it good.

Genesis 50:20 - But as for you ye thought evil against me; but God meant it unto good, to bring to pass as it is this day to save much people alive
Joseph Reassures His Brothers
15 After the death of their father, Joseph's brothers said, "What if Joseph still hates us and plans to pay us back for all the harm we did to him?" **16** So they sent a message to Joseph: "Before our father died, **17** he told us to ask you, 'Please forgive the crime your brothers committed when they wronged you.' Now please forgive us the wrong that we, the servants of your father's God, have done." Joseph cried when he received this message. **18** Then his brothers themselves came and bowed down before him. "Here we are before you as your slaves," they said.

19 But Joseph said to them, "Don't be afraid; I can't put myself in the place of God. **20** You plotted evil against me, but God turned it into good, in order to preserve the lives of many people who are alive today because of what happened. **21** You have nothing to fear. I will take care of you and your children." So he reassured them with kind words that touched their hearts.

(After Jesus crucifixion came resurrection) (Your greatest blessing comes after your greatest trials)

CHAPTER 10

Jesus is a Rock

Matthew 1:13-18

The greek word for Peter is (**Petros**) meaning a pebble or small stone Greek word that Jesus used for rock is (**Petra**) meaning a massive rock or bedrock.

In Matthew 21:42 Jesus is called the chief cornerstone. Jesus builded His church upon the solid bedrock not a small pebble.

1 Corinthians 3:11 - For no other foundation can anyone lay than that which is laid, which is Jesus Christ. We can't look to a mere human being as the foundation of the Christian church! Psalm 118:8 - It is better to trust in the Lord than to put confidence in man. Psalm 18:2 - says The Lord is my rock - Psalm 18:31- And who is a rock except our God.

Jesus is a rock in a weary land! A shelter in the time of storm!
Has he ever made a way, when you didn't have a dime?
Has he ever stepped in just right on time?

2 Samuel 22:47 - The Lord lives; and blessed be my Rock; and exalted to God, the rock of my salvation!
1Corinthians 10:4 - Jesus Christ is the spiritual rock that gave water to Israel in the wilderness that was Christ.

(Wise Man will built His house upon Jesus Christ)

Rain descended: I believe for every drop of rain that falls a flower grows. I believe that somewhere in the darkest night, a candle glows. i believe for everyone who goes astray, someone will come to show the way. I believe, I believe. I believe above the storm the smallest prayer will still be heard. Every time i hear a newborn baby cry, or touch a leaf or see the sky, then I know why I believe.

Floods came:

Winds Blew:

It was not the rain, floods and winds that cause the house to fall, it fell because it was builded upon the wrong foundation.
Psalm 11:3 - If the foundations be destroyed, What can the righteous do.

Three foundations spoken of in the Bible:

1. **Spiritual Foundation:** For other foundation can no man lay than that is laid, which is Jesus Christ. Hebrew 13:5
2. **Physical Foundation:** Hebrew 1:10 - Thou Lord in the beginning hast laid the foundation of the earth; and the heavens are the works of thine hands:
3. **World system foundation**: Paul says in Ephesians 2 that before we were saved we walked according to the course of this world, according to the prince of the power of the air.

We worship sports stars instead of God, we honor the abomination of homosexuality in our society, we outlawed God from our schools! We can trust the Lord!

CHAPTER 11

Out Into the Deep

Peter was reluctant to obey Jesus. He objected to what Jesus asked. He was thoroughly exhausted, for he had "toiled all night." He was disappointed, for he had caught nothing, and he had worked enough hours already. Despite needing to be home in bed, he had stayed and helped the Lord in His preaching by loaning his boat to Him.

Peter caught himself in the middle of his objection and obeyed. What caused the switch, the change from reluctance to willing obedience? Probably two things.

- a. Peter was pretty well convinced that Jesus was who He claimed to be, the Messiah.
- b. Peter was drawn somewhat to follow Jesus. Therefore, when he began to object to Jesus' will, there was a prick of conscience, and he obeyed his conscience. He followed his heart...
 - not his mind, thinking there were no fish.
 - not his experience, having already tried and failed to catch fish.
 - not his body, being too tired and exhausted, just incapable of going on.

Gennesaret is Luke's name for the Sea of Galilee. The fishermen are cleaning their nets after a long night, and are ready to call it a day. Their mood contrasts with that of the crowds, who are pressing in on Jesus, excited to see the young prophet.

This is Simon's Peter's first appearance in this Gospel (v. 3), and it is his first act of obedience. Given his fatigue and frustration, he would not be in the best mood at this moment. He is ready to go home, but he obeys Jesus -- putting out from the shore.

VERSES 4-7: AT YOUR WORD

4When he had finished speaking, he said to Simon, "Put out into the deep and let down your nets for a catch. Simon answered him, "Master (Greek: epistata), *we worked all night, and took nothing; but at your word I will let down the net." 6When they had done this, they caught a great multitude of fish, and their net was breaking. 7They beckoned to their partners in the other boat, that they should come and help them. They came, and filled both boats, so that they began to sink.*

CHAPTER 12

Let Your Light Shine

One of the greatest inventions of the world was the invention of the light bulb by Thomas Edison in 1879. Without light we would be in total darkness.

Matthew 5:14- 16 Ye are the light of the world. A city that is set on an hill cannot be hid. 15 Neither do men light a candle, and put it under a bushel, but on a candlestick; and it giveth light unto all that are in the house. 16 Let your light so shine before men, that they may see your good works, and glorify your Father which is in heaven.

NLT - You are the light of the world like a city on a mountain, glowing in the night for all to see. Lon't hide your light under a basket! Instead put it on a stand and let it shine for all. In the same way let your good deeds shine out for all to see, so that everyone will praise your heavenly father.

Everything we do outside after dark or inside a building has been due to the invention of the light bulb. Without light Hospitals could not function; TV, the internet and phone lines would all go down and planes and ships would not be able to navigate.

As Children of God we have a responsibility to live a life that impacts the world around us. We live in a dark world full of hatred, crime, and every sinful thing you can think of.

Many of us here today was drawn to Jesus by someone letting there light shine.

Bishop Gregory Tucker

Letting your light shine is presented by walking in the fruit of the spirit.

Galatians 5:22 -But the fruit of the Spirit is love, joy, peace, longsuffering, gentleness, goodness, faith, 23 Meekness, temperance: against such there is no law

The foundation of our faith is builded on **Love**: What is Love? This is the most misused love in the dictionary. First of all love is not and emotion, love is an act of your will. Feeling is only 20% of love but we have made it 100%. 80% of love is an act of the will. Many people who get married, married out of emotion, that why many marriages doesn't work.

Love- Affectionate concern for the well-being of others
Joy-A state of happiness, to be glad, rejoice.
Peace - freedom from the mind of annoyance distraction, anxiety, and obsession
Longsuffering - patiently enduring a great deal of trouble
Gentleness-deliberate or voluntary kindness in dealing with others
Goodness-The best part of anything generosity
Faith-The Trust of God and in his promises as made through Christ and the scriptures by which humans are justified or saved
Meekness-humbly patient, gentle
Temperance-moderation or self-restraint in action. Self-Control

CHAPTER 13

Kill are be killed

2 Samuel 8:1-2
1 Samuel 15:1-3

The Philistines had troubled Israel for centuries, and often denominated Israel. Philistines was the masters of the use of Iron weapons and their chariots was even made of Iron but through the help of God David conquered their capitol city (Metheg Ammah) and subdued them.

Then he defeated Moab. Forcing them down to the ground, he measured them off with a line. With two lines he measured off those to be put to death and with one full line those to be kept alive. So the Moabites became David's servants, and pay taxes to Israel.

Now David has the power to allow some Moab people to live or die. Out of these **natural battles** are **spiritual lessoning** the still apply to our life today. (The issue of life and death doesn't get anymore serious is this)
First when you here of someone being in serious accident the first thing that comes to mind is, are they alive or dead.
(It's amazing how life and death can hinge on one moment)
Emperor could announce death upon a galitor in the Roman area
(thump up means to live - thump now mean to die)
Person on death row life could be pardon by the governor or not

There are some thing in our life just have to die. If you have a garden, you can allow weed to grow in that garden. In order to preserve life you have to kill certain things or else it will kill you.
The naval seals had to make a decision to kill Bin Lamdo or kept him alive. They chose to take him out. Terrroist can't be reason with. Sin can't be reason with either you kill it or it will kill you.

If we are going to live for Christ there are certain things of our past and present that our old nature carve for that we have to kill on a daily basic. Paul said I die daily.
Moab was an eternal enemy of Israel. Lot slept with his two daughters.
If we don't response to the mercy of God than we will have to suffer with the judgment of God.
Moab people began to harass and torment over and over again, but finally David has the upper hand over them. What a picture of victory now that his enemies had been disarmed and laying at his feet.

That can live but that one has to die, that one can live but that one has to die. Line of separation was created. There are some thing you cannot toy orate. You can't pet. (Habit dies today) (Addiction dies today) unforgiveness, and hatred and anger dies today.

Take the sword of the Spirt with is the Word of God and separate somethings. **good from the bad, righteous from the unrighteous, acceptable from the unacceptable**

Roman 8:13 - For if ye live after the flesh, ye shall die; but if you through the Spirit do **mortify t**he deeds of the body ye shall live.
This generation wants the grace of God but doesn't to kill the works of the flesh.

Anak was the first giants on the face to the earth, and he had three sons. Number 13:33 -33 And there we saw the Nephilim, the sons of Anak, who come of the Nephilim: and we were in our own sight as grasshoppers, and so we were in their sight. Three of the sons of the giant kept the children of Israel out of the Promise land.

40 years later Judges 1:20And they gave Hebron unto Caleb, as Moses had spoken: and he drove out thence the three sons of Anak

a little frustration become and extra marital a fare
a little drink become alcoholism
a little anger becomes a root of bitterness
a little drug usage becomes a drug addiction
a little rebellion become destruction
Galatians 5:9 - A little leaven leavens the whole lump.
A little poison will kill you
It the little foxes that spoil the vine

Ephesians 6:17 - (take the **sword of the Spiri**t which is the word of God) There are times you may have to kill for your **protection, survival**

(Remember God Grace comes before Judgment) if don't accept his grace that judgment is bound to get you.

Luke 10:19 - Behold, I have given you authority to tread upon serpents and scorpions, and over all the power of the enemy: and nothing shall in any wise hurt you.

CHAPTER 14

Living in the 4th Dimension

(Keys to access Heavens Throne Room)

We live in a three dimension world. Spirit, Soul Body. It is not until our human spirit is renewed, regenerated, revived, through the power of the Holy Spirit that we are able to reach the fourth dimension world.

It is though prayer, fasting, and giving our complete life to God that we experience the power of God operating in and around us.

I strongly believe that through prayer(spending time with God) and study of His Word (learning about father, son and holy spirit)(the fruit of the spirit) and the (gifts of the spirit) are brought to full manifestation in our lives.

Galatians 5:22 - But the fruit of the Spirit is love, joy, peace, long suffering, gentleness, goodness, faith, 23 Meekness, temperance: against such there is no law.

1 Corinthians 12:8-10 - 8 For to one is given by the Spirit the (word of wisdom); to another the (word of knowledge) by the same Spirit; 9 To another (faith) by the same Spirit; to another the (gifts of healing) by the same Spirit; 10 To another the (working of miracles;) to another (prophecy); to another (discerning of spirits;) to another (divers kinds of tongues) to another the (interpretation of tongues).

In Act 12 chapter I often ask myself the question why was Peter spared and James killed. Could it be that there was more prayer going up for Peter and James.

1 Now about that time Herod the king stretched forth his hands to vex certain of the church. 2 And he killed James the brother of John with the sword. 3 And because he saw it pleased the Jews, he proceeded further to take Peter also. 5 Peter therefore was kept in prison: but prayer was made without ceasing of the church unto God for him.

You can tell how powerful a church is by looking at two things. Prayer meeting and Bible study.

(Key of Prayer) delivered Peter from Jail and in Acts 25:16 - And at midnight Paul and Silas prayed, and sang praises unto God: and the prisoners heard them. 26 And suddenly there was a great earthquake, so that the foundations of the prison were shaken: and immediately all the doors were opened, and every one's bands were loosed. Isaiah 38:1 -2 Then (Hezekiah)turned his face toward the wall, and prayed unto the Lord. Go, and say to Hezekiah, Thus saith the Lord, the God of David thy father, I have heard thy prayer, I have seen thy tears: behold, I will add unto thy days fifteen years.

(Key of Praise) - (Power Released against incoming satanic emissaries)

(Key of Praise) Jehoshaphat - 2 Chronicles 20:1 - It came to pass after this also, that the children of Moab, and the children of Ammon, and with them other beside the Ammonites, came against Jehoshaphat to battle. 22 And when they began to sing and to praise, the Lord set ambushments against the children of Ammon, Moab, and mount Seir, which were come against Judah; and they were smitten.

(Key of Worship)- Mark 5:1-19 - 1 And they came over unto the other side of the sea, into the country of the Gadarenes. 2 And when he was come out of the ship, immediately there met him out of the tombs a man with an unclean spirit, 3 Who had his dwelling among the tombs; and no man could bind him, no, not with chains: 4 Because that he had been often

Bishop Gregory Tucker

bound with fetters and chains, and the chains had been plucked asunder by him, and the fetters broken in pieces: neither could any man tame him. 5 And always, night and day, he was in the mountains, and in the tombs, crying, and cutting himself with stones. 6 But when he saw Jesus afar off, he ran and worshipped him, 7 And cried with a loud voice, and said, What have I to do with thee, Jesus, thou Son of the most high God? I adjure thee by God, that thou torment me not. 8 For he said unto him, Come out of the man, thou unclean spirit.

The Greek word for worship here is the physical act of bowing down instead of the showing worth in the way we normally think of positive worship.

CHAPTER 15

God is looking for Men of Faith

Number 13:25-33
1 Timothy 6:12

Men of Faith have done Great Things, not men who fear and tremble and are afraid. Men of Faith have hearts of steel and a boldness that comes from knowing they can do all things through Christ who strengthens them.

As Israel approached the Jordan River, Moses sent out twelve spies to investigate the Promised Land. One spy from each of the twelve tribes of Israel entered Canaan, explored the land and returned with a report. All twelve had the same external experiences, but the internal conclusions of ten differed markedly from the other two.

Similarities
- All twelve spies were leaders in their tribes
- All twelve spies received the same promise
- All twelve spies received the same opportunities

Differences (Majority Report)
- Ten said no
- Misunderstood their mission
- Saw circumstances rather than God

Minority Report
- Two said "go"

Bishop Gregory Tucker

- Understood their mission
- Saw God rather then circumstances

The ten spies displayed a horrible attitude seeing things from a pessimistic perspective. Doubting the very God who had brought them through the Red Sea. Pessimistic people always see the glass as being half empty and not half full. But in order to walk with God in this day and age we must walk by faith and not by sight. We must stave our doubt and feed our faith.

Joshua and Caleb returned with and enthusiastic positive report. They never doubted the Israelites could take the land. They based their glowing report on God's track record with the nation through the desert. They knew the obstacles facing them but they also knew nothing could stand in the way of God. Yes there are giants in the land, but they're midgets compared with our God.

How are you looking at the problems you face today. Are you allowing them to make you soft and weak, cold and harden sweet to taste.

A young woman went to her grandmother and told her about her life and how things were so hard for her. She did not know how she was going to make it and wanted to give up. She was tried of fighting and struggling. It seemed as one problem was solved, a new one would pop up. Her grandmother took her to the Kitchen. She filled three pots with water and placed each on a high fire, and soon the pots came to boil. In the first pot she placed carrots. In the second pot she placed eggs and in the last she placed ground coffee beans. She let them sit and boil without saying a word. In about twenty minutes she turned off the burners. She fished the carrots out and placed them in a bowl, she pulled the eggs out and placed them in a bowl, then she ladled the coffee out and place it in a bowl.

Turning to her granddaughter she asked, Tell me what you see.
Carrots, eggs, and coffee, she replied.

Her grandmother brought her closer and asked her to feel the carrots. She did and noted that they were soft. The grandmother then asked the granddaughter to take an egg and break it.

After pulling off the shell, she observed the hard boiled egg. Finally the grandmother asked the granddaughter to sip the coffee. The granddaughter smiled as she taste its rich aroma then asked, What does ti mean grandmother?

Her grandmother explained that each of these objects had faced the same boiling water (adversity)
The carrot went in strong hard, and unrelenting however after being subjected to the boiling water, it softened and became weak.
The egg had been fragile, but after sitting through the boiling water its inside bad become hardened.
The ground coffee were unique, however after they were in the boiling water they changed the water.
When adversity knocks on your door which are you a carrot, an egg or a coffee bean!

The ten naysayers spread anxiety throughout Israel's camp. Their rotten attitudes infected the whole congregation. Deut 1:28 - Our brethren have discouraged our hearts saying The people are greater and taller than we.

Joshua and Caleb:
Obeyed God
Insisted they should enter and possess the land
Displayed courage rooted in faith
Felt calm assurance

Our attitude determines our approach to life.
Our attitude determines our relationships with people
Our attitude is often the only difference between success and failure
Our attitude can turn problems into blessings

Fight on Men!
Fight till mouths of the lion are muzzled
Fight till the flames of the fiery furnace are quenched
Fight till the strongholds of the devil are conquered
Fight till the battles of temptation are won
Fight till the walls of the enemy are penetrated
Fight till the raging storms of life are stilled

CHAPTER 16

Access Granted

Matthew 16:17-19 - 17 And Jesus answered and said unto him, Blessed art thou, Simon Barjona: for flesh and blood hath not revealed it unto thee, but my Father which is in heaven. 18 And I say also unto thee, That thou art Peter, and upon this rock I will build my church; and the gates of hell shall not prevail against it. 19 And I will give unto thee the keys of the kingdom of heaven: and whatsoever thou shalt bind on earth shall be bound in heaven: and whatsoever thou shalt loose on earth shall be loosed in heaven.

Keys are used to lock or unlock doors. The specific doors Jesus has in mind here are the doors to the Kingdom of Heaven. Jesus is laying the foundation to His Church. The disciples will be the leaders of this new institution called the church, and Jesus is giving them the authority to either grant access to the Kingdom.

Matthew 27:50- 53 Jesus, when he had cried again with a loud voice, yielded up the ghost. 51 And, behold, the veil of the temple was rent in twain from the top to the bottom; and the earth did quake, and the rocks rent; 52 And the graves were opened; and many bodies of the saints which slept arose, 53 And came out of the graves after his resurrection, and went into the holy city, and appeared unto many.
How to enter the Kingdom of Heaven - John 3:3-Jesus answered and said unto him, Verily, verily, I say unto thee, Except a man be born again, he cannot see the kingdom of God.

It is through the preaching the gospel those who respond in faith and repentance are allowed access to the Kingdom of Heaven. Righteousness, Peace and Joy in the Holy Ghost.

Peter used the First Key to unlock the door of salvation that was closed to the Gentiles.
Preaching of the Gospel of Christ. 3000 souls was brought into the Kingdom of God through one message, this is the largest among of souls recorded in history.

Peter was license by God to preach, many so called preachers today have never been called by God, the same in Jeremiah day. Jeremiah 23:21 - I have not sent these prophets yet they ran: I have not spoken to them yet they prophesied.

(Benefits of being in the Kingdom)
Roman 14:17 - 17 For the kingdom of God is not meat and drink; but righteousness, and peace, and joy in the Holy Ghost. 18 For he that in these things serveth Christ is acceptable to God, and approved of men

Since I am in the Kingdom of God and the Kingdom of God is in me I at entitle to God's Righteousness, Peace and Joy in the Holy Ghost.

Righteousness Peace and Joy that the Kingdom of God don't want to be a part of the kingdom. Come on everything - that love in the kingdom

God's Righteousness - 2 Cor 5:21 - 21 For he hath made him to be sin for us, who knew no sin; that we might be made the righteousness of God in him.

That why I must do everything in my power to live a life that is pleasing to God.
If I live right Heaven belong to me.

God's Peace - Philippians 4:7 - And the peace of God, which passeth all understanding, shall keep your hearts and minds through Christ Jesus.

Joy in the Holy Ghost -

It is in God that we discover our origin, our identity our meaning our purpose our significance and our destiny.

Name of Jesus it another Key -
Cast out demons - Acts 16:18
Heal the sick - Acts 3:6
Pray to the father in the name of Jesus

The Blood of Jesus is another Key

Ephesians 2:12 - That at that time ye were without Christ, being aliens from the commonwealth of Israel, and strangers from the covenants of promise, having no hope, and without God in the world: 13 But now in Christ Jesus ye who sometimes were far off are made nigh by the blood of Christ.

There is a fountain filled with blood flowing from Emanuel veins sinner plunge beneath that flow and cleanse all guility strain.

The priest would have to go into the Holies of Holies once a year on **Yom Kippu**r to atone for his and the people sin. He have to walk in backward and get out of there before he has any evil thought.

The blood prevails like it did in olden day!
I know it was the blood

CHAPTER 17

All in one and one in All

Acts 4:31 - And when they had prayed, the place was shaken where they were assembled together; and they were all filled with the Holy Ghost, and they spake the word of God with boldness.

National Day of Prayer calls on all people of different faiths in the United States to pray for the nation and its leaders. It is held on the **first Thursday of May each year.**

The International Day of Prayer is was held on June 9 of this year 194 countries was involved. On that day people all over the world gathered for Scripture reading, Worship and prayer for the year ahead.

In order for the Church of God to move forward we need a tuneup in the area of prayer. **Prayer is like gasoline to a car.** If the car has no gas it cannot run. To many christians are trying run their spiritual cars on empty looking for God to work miracles in their life.

Be honest with me, how many of you have run out of gas while driving your car.

- It is to run out of gas when fill in stations are all around up. Here you are stall on the side of the road and someone stop and ask you what's the problem and you say something like I don't know what the problem is, when you know quit well you ran out of gas.

- **It is embarrassing** when someone ask you to pray and you can't remember the Lord prayer. Our Father which art in Hell, Hallowed be thy son, Thy kingdom don't come. Thy will be done in heaven as it is in earth. Give me this day our daily bread and forgive me my debts as I don't forgive others.
- **It is embarrassing** when leaders sit in the back of the church scared someone might call them to open up the service for prayer.

Lack of Prayer produces Canal Christians.
- Have a complaining spirit
- Have no reverence for authority
- Have a selfish spirit
- Call what is right wrong and what is wrong right

A. When to Pray

James 5:13 - Is any among you afflicted? let him pray. (Distress, suffering hardships) trouble other than sickness. Marriage problems - Pray, Lost of Job Pray, misunderstanding among family members pray, all problems other than sickness.

When you back is against the wall and you don't see any way out pray.

B. **When the sentence of death is pronounced upon someone**

Isaiah 38:1-5-**1** In those days was Hezekiah sick unto death. And Isaiah the prophet the son of Amoz came unto him, and said unto him, Thus saith the Lord, Set thine house in order: for thou shalt die, and not live. 2 Then Hezekiah turned his face toward the wall, and prayed unto the Lord, 3 And said, Remember now, O Lord, I beseech thee, how I have walked before thee in truth and with a perfect heart, and have done that which is good in thy sight. And Hezekiah wept sore. 4 Then came the word of the Lord to Isaiah, saying, 5 Go, and say to Hezekiah, Thus saith the Lord, the God of David thy father, I have heard thy prayer, I have seen thy tears: behold, I will add unto thy days fifteen years

C. **When you have to go to Court**

Luke 18- Widow came to the unjust judge repeatedly appealing for justice against someone who had harmed her. The Judge ignored her for a while,

but eventually she wore him out. I fear neither God nor man, he said to himself but this woman is driving me crazy; I am going to see that she gets justice, because she is wearing me out with her constant requests.

D. **At Midnight**

Acts 16:25 - And at midnight Paul and Silas prayed, and sang praises unto God: and the prisoners heard them.

E. In your secret closet/Together with other Believers

Matthew 6:6 - But when you pray go away by yourself shut the door behind you and pray to your Father secretly. Then your Father who knows all secrets will reward you.

Use Matthew 6:9-13 as a model prayer

Our Father - A personal relationship with God
Which art in heaven - Faith
Hallowed be thy name - Worship
Thy Kingdom Come - Expectation
Thy Will be done in earth as it is in heaven - Submission
Give us this day our daily bread - Petition
And forgive us our debts - Confession
As we forgive our debtors - Compassion
And lead us not into temptation but deliver us from evil - Dependence
For thine is the Kingdom and the power and the glory forever - Acknowledgment

Why should we Pray

- Keep us in tune with God - Lord whatever you doing in this season don't do it without me
- It allows you to get rid of your heavy load
- It purges you from all sins
- Help us keep the unity of the faith in the bone of peace
- Tears down strongholds
- Prayer will Fix it

Bishop Gregory Tucker

- Cast all your anxiety on Him because he cares for you

1 Peter 5:7 -7 Casting all your care upon him; for he cares for you

Psalm 55:22 - Cast thy burden upon the Lord, and he shall sustain thee: he shall never suffer the righteous to be moved

CHAPTER 18

My Hope is in God

Psalm 42:5 Why art the cast down, O my soul? and why art thou disquieted in me? Hope Thou In God

Whether on the battlefield or at the sickbed of a loved one, no words in the English language are more devastating than, "There is no hope"

Of all people who are living, the Christian is the only one who has true hope. Hebrew 11:1 Now faith means we are confident of what we hope for convinced of what we do not see. Hope is linked with faith because faith is the ground of our hope and hope is the object of our faith.
Hope of eternal life
Hope of Salvation
Hope laid up in heaven
Hope of resurrection from the dead
Hope of the gospel

There was a man who tried to sail the Atlantic Ocean but his vessel went down because of bad weather and he existed on a raft for almost eighty days. He was finally rescued and ask what keep him alive for all those days at sea. He say one word Hope.

We can live forty days without food, eight days without water, four minutes without air, but only a few seconds without hope.

Bishop Gregory Tucker

What an anchor provides for a ship, hope provides for the soul. Both provide necessary stability amidst the storms of life, something to hold on to should you find yourself floundering in the ditch of despair. The world say that hope is an optimistic wish that something good will happen. But the believers hope is based on God's unchanging Word. By patiently relying on what God says you will have all the hope necessary with all the certainty you will ever need, especially when tragedies enter our lives unexpectedly.

Putting your hope in Christ will keep you from being wrecked by the crushing events of life.

According the the scripture Hope is Good, Blessed, Living, Glorious, Sure Steadfast, the anchor of the soul.

Those who have this hope must:
Purify themselves - 1 John 3:3

Rejoice in their hope - Rom 12:12 -

Remain steadfast - Heb 6:18-19 -
Wait - Gal 5:5 -
If God is dead what makes the flower bloom
If God is dead what makes summer comes in June
If God is dead who listens and answers prayer
If God is dead who mens a broken heart
If God is dead who keeps night and day apart
If God is dead who can tell me where His body lies
I glad I know he lives in me, I can feel him moving through the trees in the wind and the breathes, I can see him shining in through the night in the stars that shine so bright
If God is dead what makes my life worst living

CHAPTER 19

"Bruised but not broken, Dimmed but not out"

Isaiah 42:5-9

At the beginning of the year perhaps more than any other time of the year we become reflective, and look back over the year and over our life. We think about things that went right and things that went wrong. We think about victories and we think about defeats. We think about mistakes that we made and how there are things we wish we could do over again or words we wish we could have taken back. At this time of the year resolutions are made, diets are started, and exercise machines are dusted off and put to use again. At this time of the year new things are tried.

As a Christian this is a time that we can evaluate our walk with God.

Did I give my best to God this past year? Did I pray like I should have? Did I witness like I should have? Did I read the word of God like I should have? Did I attend church and was I faithful to God as I should have? Was God number one in my life?

Isaiah is often referred to as "The Messianic and Eagle Eye Prophet because of his many prophecies that were fulfilled in Jesus. The New Testament quotes and applies more scriptures from the book if Isaiah than any other Old Testament prophet.

Isaiah was God's spokesman to Judah & Jerusalem at time when the nation was immersed in sin. He spoke God's indictment against their sins, urging them to repent.

He then foretold destruction upon them if they did not return to God.

In the midst of these dire warnings, Isaiah also foretold of a bright future with the coming Messiah. God would not forget His covenant made to Abraham, Isaac, Jacob, and David. He would spare a remnant of the nation o Israel out of which would come the Messiah and His new kingdom.

America has forgotten God:

- More concerned with being politically correct than right biblically
- Separation of Church & State - Pushed God out of Government
- Out of our court system
- Out of our Schools
- Out of Christmas

Here in New York a teacher can place a copy of the Koran on his desk, but if he brings a Bible to Class, he could lose his job. Our society has totally lost it s moral compass.

Our country, our society, our churches are growing more corrupt and more evil by the day. How long can a world last when it kills it's unborn, fathers rape their daughters, mothers molest their sons, and child molestation has become an epidemic same sex marriage is legalized.

God has not Forgotten America:

God gave Noah's generation 120 years of warnings, but after that he said, Enough and brought a flood and destroyed everything. America became a nation on July 4, 1776 that would make our nation come July 4 2015 239 years old. That means God has extended his mercy for us some 119 years. Isaiah's prophecy says: "A bruised reed shall he not break. A reed is a tall stalk or plant with a hollow stem, usually found in marshy areas or near a supply of water. It's a tender plant, it bends very easily, it can break with a

strong wind or swift current of water. This tender reed that the scripture is talking to us about is a reed that can only be bent so far. It can only take so much; once enough pressure has been applied it can break and never be repaired again. Aren't you glad that God has told us in His word that He will not break the bruised reed?

Yes, the immorality, cares of life and disappointments may have bruised us all but God said a bruised reed shall be not break. we've all been hurt, were all struggling, were all in need of relief, we've all been let down, were all struggling financially, we all have sickness, were all tried, were all raising families and trying to make ends meet, we all been bruised.

A bruised reed shall he not break, and a dimly burning wick will he not quench:

His arm is not to short that he can't reach you at the point of your need. His eye has not gone blind that he cannot see you, but his eye is on the sparrow and I know he watches over me. His power has not diminished that he can't mend your broken life. His healing virtue has not run dry that he can't heal your body. His peace has not vanished that he can't still bring you through the storms of this life. He is still a friend that sticks closer than a brother. The name of the Lord is still a strong tower that the righteous can run into and be saved. The Lord is not slack concerning his promise.

God sees some wicks that are still smoldering. These wicks once were on fire for God, they knew there purpose and their calling.

Flags Banner & Standards used interchangeably throughout the Word of God.

Standards are the poles that the flags or banner are waves on: Pole represent Jesus Christ as being our standard. Jesus hung on a pole (cross). When we rise the pole up we are rising up Jesus Christ.

The word standard comes from a hebrew word Degoll & Nase Degoll means to flaunt fly a banner Nase means to signal. **Claim a Territory**

Bishop Gregory Tucker

Song of Songs 6:4 - We are awesome as an army with banners.

Isaiah 31:8-9 - Then shall the Assyrian fall with the sword, not of a mighty man; and the sword, not of a mean man, shall devour him: but he shall flee from the sword and his young men shall be discomfited. and he shall pass over to his strong hold for fear and his princes shall be afraid of the ensign, saith the Lord, whose fire is in Zion, and his furnace in Jerusalem.

Jeremiah 50:2 - Declare ye among the nations, and publish, and set up a standard publish and conceal not.

Exodus 17:15 - And Moses built an altar, called the name of it Jehovah Nissi the Lord our Banner.

CHAPTER 20

Obeying God Instructions

Matthew 7:21-28

A Good Christian is a good citizen. You keep the law of the land. You don't run red lights. You don't purposely over park. And you don't evade your income tax. You maintain the speed limit. Someone has said, **"The last thing to get saved on a Christian is his right foot.**
Obey to carry out orders given unto you!

The Sermon on the Mount cover three chapter Matthew 5, 6 & 7 describing the character and blessedness of the citizens of the Kingdom of God. Within these chapters He teaches about the :

Obeying God is the Key to a Happy Life
Beatitudes
Blessed are the **poor in spirit**, for theirs is the kingdom of heaven
Blessed are those who **mourn** for they call be **comforted**
Blessed are the **meek** For they shall **inherit the earth**
Blessed are those who **hunger and thirst for righteousness** for they shall be **filled**
Blessed are the **merciful** for they shall **obtain mercy**
Blessed are the **pure in heart** for they shall **see God**
Blessed are those who are **persecuted for righteousness** sake For theirs is the **Kingdom of Heaven**
Blessed are you when they **revile and persecute you,** and say all kinds of evil against you falsely for my sake.

CHAPTER 21

Five Principles that bring Angels alongside us to help us:

1. **Authority** (Mark 1:21-27)
 A. Why is there no arguing or fighting in Satan's Kingdom? (Matthew 12:24-26)
 1. Because they are under Satan's authority
 2. He has many lying and evil spirits working under his authority

 C. The good angels respond to God's authority
 1. Angels are watching the issue of authority in our lives
 2. If Christians are out of God's authority, then the angels cannot come along and assist in God's purposes for their lives - (Acts 19:13-16)

 C. Four areas of authority to submit to (James 4:7)
 1. Sovereign imperial Authority
 2. His Word: God and His Word are one.
 3. Conscience: It is a testimony and a witness to us.
 4. Delegated Authority

2. **Sacrifice**
 A. Abraham and Isaac (Genesis 22:1-14)
 B. David's Sacrifice - Sacrifice must cost something - 2 Samuel 24:24
 C. Zechariah in the temple, offering sacrifice (Luke 1:5-25)

D. Samson's father: Manoah - Judges 13:19-23
 E. Gideon - Judges 6:19

3. **Prayer**
 1. Angels respond to the prayers of mankind
 A. Abraham's prayer of intercession for Sodom and Gomorrah
 B. Daniel's prayers and the consequences
 C. Peter in prison (Acts 12)

4. **Almsgiving**
 A. What we do with our money affects angels.
 1. The story of Cornelius (Acts 10:4)
 2. God's Angels watch what God's children do with their income.
 3. Giving is a form of sacrifice, and angels are watching that sacrifice

5. **Praise and Worship**
 A. Our praise to God influences the angels.
 B. 2 Chronicles 20:22
 C. God ambushes with angels
 D. Our praise brings the help of angels

CHAPTER 22

Promise Anointing

Luke 4:18 - The Spirit of the Lord is upon me, because he has chosen me to bring good news to the poor.

He has sent me to proclaim liberty to the captives and recovery of sight to the blind, to set free the oppressed and announce that the time has come when the Lord will save his people. That **anointing** has been placed down to us as believers today.

Isaiah 10:27 - **And it shall come to pass in that day, that his burden shall be taken away from off thy shoulder, and his yoke from off thy neck, and the yoke shall be destroyed because of the anointing.**

Every born-again, Spirit filled child of God has the anointing upon their life. However each individual is responsible for **keeping** and i**ncreasing the level of anointing**. That is why some walk in a greater anointing than others. The Word teaches Christians to be filled and continually filled with God's Spirit, ensuring a fresh outflow of the anointing. Eph 5;18 - **And be not drunk with wine, wherein is excess; but be filled with the Spirit**

It should be noted the after the outpouring of the Holy Ghost recorded in Acts 2, the disciples experienced another outpouring soon afterwards.

Acts 4:31 - **And when they had prayed, the place was shaken where they were assembled together; and they were all filled with the Holy Ghost, and they spake the word of God with boldness**

In Ezekiel's prophecy 47:3-6 gives believers a clear picture of how the level of Gods presence and power can increase in the lives of His people. Water, streams and rivers often refer to the presence and flow of God's Spirit. The highest attainable level of God's throne to individuals, groups, or nations and is often referred to as the sea.

Level 1 - Ankle Deep - Those believers who desire a shallow experience with God. Not in a position to affect anyone around them with the Gospel.

Level 2 - Knee Deep - Pray but dare not wander deeper in the unknown realm of what God has for them.

Level 3 - Waist Deep - Active in the things of God and interacts with others around them. They love the Lord and are somewhat involved in the activities of the ministry but are not fully committed.

Level 4 - Fully Immersed - Represents the believer who lives by faith and does not make decisions according to outward appearances, but has absolute faith in the voice of the Word and the Spirit. These believers are those who produce fruit, who are led by the Spirit and are not influenced by the flesh or natural surround-ings. They are a blessing to others, bringing light, hope, joy, and healing to those who are yoked in bondage.

King David asserts that the anointing of fresh oil upon his life will ensure the defeat of his enemies. Psalms 92:1

The Five Ingredients of the anointing oils Exodus 30:17-33

Myrrh. **_Myrrh(Prayer)_** is a necessary ingredient in embalming fluid; it is also used as a purifier. In our walk with the Lord, we must be cleansed and purified from our sins. And when God delivers us, we must become dead to those sins--as dead as a body that has been embalmed, no longer able to respond to sinful impulses.

"Likewise you also, reckon yourselves to be dead indeed to sin, but alive to God in Christ Jesus our Lord. Therefore do not let sin reign in your mortal

body...but present yourselves to God as being alive from the dead, and your members as instruments of righteousness to God" (Rom. 6:11-13).

Cinnamon. **Cinnamon(Praise)** is a spice used to add a sweet smell to the anointing oil. God not only saves us and allows us to become dead to our old way of living, He also fills us to such a degree that our lives can exude the sweetness of our Savior. We can begin to take on His gentle, kind and loving fragrance. "Walk in love," Ephesians 5:2 tells us, "as Christ also has loved us and given Himself for us, an offering and a sacrifice to God for a sweet-smelling aroma."

Cane. **Cane, or calamus, (Love)** is also used to sweeten the anointing oil. The quality of sweetness is so important to the Lord that He requires us to be doubly sweet--to overflow with the kindness, gentleness and love of Christ.

Cassia. (Faith) The branches of the cassia herb retain moisture and must be planted in a swampy area near the banks of a river in order to survive. So must we be planted deep in the Living Water in order to experience the anointing of God. As Jeremiah 17:7-8 says, "Blessed is the man who trusts in the Lord, and whose hope is the Lord. For he shall be like a tree planted by the waters, which spreads out its roots by the river, and will not fear when heat comes; but its leaf will be green, and will not be anxious in the year of drought, nor will cease from yielding fruit.

Olive Oil. **(Perseverence & Endurance))** The process required to get olive oil is painful and intense. First, the trunk of the olive tree must be shaken harshly, causing the olives to fall to the ground. Then the olives must be beaten and smashed until the liquid runs out. The oil is used both to dress wounds and, in the Jewish tradition, to anoint objects or vessels that are earmarked to be used for the glory of God.

The process by which we are anointed for God's service is not much different. If we seek the anointing, we must expect to be shaken and crushed for the cause of Christ. Trials and temptations will beat upon us. But if we persevere with an attitude of love, humility and thankfulness, the oil of the Holy Spirit will flow out of us to others. To this God adds

the double-sweetness of cane, causing us to love even our enemies and rise above the fiery darts that would divide us. This leads us to be steadfast like cassia, "rooted and grounded in love" so that we "may be filled with all the fullness of God" (Eph. 3:17,19). Then, when the circumstances of life crush and break us, we are able to persevere with a right attitude and find ourselves being poured out, like olive oil, in service to others.

NEVER DEFEATED When the five key ingredients of the anointing are placed within our spirits, we might be broken, but we cannot be defeated. The power of the prayer becomes our myrrh, our purifier, cleansing us from the power of sin. Then the cinnamon & Calamus the sweetness of God, is able to fill us with His Praise and love. Cassia is our faith to believe God in spite of any situation and the olive oil will give us the perseverance & endurance we need in these last days.

CHAPTER 23

"Have You Receive Since You Believed"

Promise - An agreement to do or not to do something
There are many teaching today that tell you it's not necessary to speak in tongues. They say it was for the early church and not for our modern day church. I personally don't want to belong to a church that teaches against speaking in tongues, because to teach would be going against the Word of God.

Peter quoted this passage on the day of Pentecost. The outpouring of the Spirit predicted by Joel occurred on Pentecost. While in the past God's Spirit seemed available to kings, prophets and judges, Joel visualizes a time when the Spirit will be available to every believer. Ezekiel 39:28 also spoke of an outpouring of the Spirit upon the house of Israel.

Promise of The Holy Spirit

Acts 19:2 - 2 He said unto them, Have ye received the Holy Ghost since ye believed? A person cannot receive the Holy Spirit without first believing in Gospel of Jesus Christ. Acts 19:6 - And when Paul had laid his hands upon them, the Holy Ghost came on them and they spake with tongues, and prophesied.

Acts 10:44 - While Peter yet spake these words, the Holy Ghost fell on all them which heard the word. And they of the circumcision which believed were astonished, as many as came with Peter because that on the Gentiles

also was poured out the gift of the Holy Ghost. For they heard them speak with tongues, and magnify God.

2 Peter 1:4 - Whereby are given unto us **exceeding great and precious promises:** that by these ye might be partakers of the divine nature, having escaped the corruption that is in the world through lust.

Acts 1:8 - But ye shall receive power, after that the Holy Ghost is come upon you: and ye shall be witnesses unto me both in Jerusalem, and in all Judaea, and in Samaria, and unto the uttermost part of the earth.

I do believe that without the Holy Spirit being able to manifest himself against us the church becomes powerless.

A powerless church is a weak church. In a weak church people are sinful, unhappy, selfish, and unpleasant to be around.

Luke 24:49 - 49 And, behold, I send the promise of my Father upon you: but tarry ye in the city of Jerusalem, until ye be endued with power from on high.

Acts 2:1-4-1 And when the day of Pentecost was fully come, they were all with one accord in one place. 2 And suddenly there came a sound from heaven as of a rushing mighty wind, and it filled all the house where they were sitting. 3 And there appeared unto them cloven tongues like as of fire, and it sat upon each of them. 4 And they were all filled with the Holy Ghost, and began to speak with other tongues, as the Spirit gave them utterance.

CHAPTER 24

(Second Adam)

Genesis 1:27 - So God created man in his own image, in the image of God created he him; male and female created he them. 28 And God blessed them, and God said unto them, Be **fruitful,** and **multiply**, and **replenish the earth,** and **subdue it**: and have **dominion** over the fish of the sea, and over the fowl of the air, and over every living thing that moves upon the earth.

John 10:10 - 10 The thief cometh not, but for to **steal,** and to **kill,** and to **destroy**: I am come that they might have life, and that they might have it more abundantly.

Earth was created before mankind was formed because it was necessary in order for man to be a legitimate ruler. Man was created to dominate, and it is impossible to dominate nothing.

The earth was given to mankind as a **colony** from **heaven.** Psalm 115:16 -The heaven, even the heavens, are the Lord'S: but the **earth** hath he given to the children of men.

The mandate of God to Adam was to be king over a property. Every kingdom must have territory. The word kingdom derives from the phrase "King Domain. Domain refers to the property, the territory over which a king exercises his dominion. A kingdom then isa king's territory. Without territory a king is not a king because he has nothing to rule over.

Before Adam had sin a plan was in place for the Son of God to restore the Kingdom of the earth back to mankind. Matthew 4:17 - From that time Jesus began to preach, and to say, Repent: for the kingdom of heaven is at hand. (Change your mind)(has arrived) 1 Corinthians 15:45 - And so it is written, The first man Adam was made a living soul; the last Adam was made a quickening spirit.

46 Howbeit that was not first which is spiritual, but that which is natural; and afterward that which is spiritual. 47 The first man is of the earth, earthy: the second man is the Lord from heaven.

The Lord Jesus is the **last Adam** and the **Second Man.** He is the last man to be without a sin nature. His nature was both human and divine. He was the second man – the man from heaven. As the God-man He could be the suitable sacrifice for the sins of the world. The Bible says that Jesus offered Himself as the sacrifice for sin.

When the Shan of Iran was ousted by Islamic fundamentalist revolutionaries in 1979, he fled to another country. Although he was still called the shah the Iranian word for king, it was mainly a courtesy. In reality he was no longer a king because he no longer had a domain. He was a king in exile. You cannot be a king in exile. You cannot be a king without territory. This is why Christ had to come to earth to get our earthly kingdom back. We are supposed to be rulers, but without our territory we cannot fulfill or destiny.

Real Estate is important because it is the only form of earthly wealth that never loses it value. When Adam, the king of the earth rebelled against God, the High King of Heaven, he lost his Kingdom and with it his place as king.

The Bible says that Jesus Christ is the second Adam who came to restore what the first Adam lost. Because Jesus restored the Kingdom, all who are citizens of the Kingdom of heaven can now be Kings and Queens of the earthly realm again.

Four Principles that help explain the basis of our authority on earth:
1. The first thing God gave man was territory; (land)
2. The earth was created to give man kingship legitimacy
3. The domain of earth is mankind's legal right power, and authority of rulership
4. Man's kingship is by privilege not by creative right - God controls the domain because He created it. He rules it by creative rights. We rule it because or privilege. We are Kings and queens by delegation, not by creation. God gave us rulership but not ownership.

Let them have dominion, he transferred the legal rights to the earth to us.

After we have been raptured away from earth we will come back to rule in the new earth that God will fashion when this earth passes away.

Rev 21:1 - And I saw a new heaven and a new earth: for the first heaven and the first earth were passed away; and there was no more sea.

God is not to blame for human evil and suffering. We brought these things on ourselves by our own selfishness and rebellious spirit. God wants to help but won't intervene unless invited to do so by Kingdom citizens who know their dominion authority. Through prayer we invite God to act in our domain.

Matthew 18:18 - Verily I say unto you, Whatsoever ye shall bind (lock Up) on earth shall be bound in heaven: and whatsoever ye shall loose (permit) on earth shall be loosed (unlock) in heaven.

Whatever we allow in society, Heaven will not stop, and whatever we disallow in society, Heaven will make sure it does not happen.

Note: In the Kingdom of heaven there is no economic crisis and there are no shortages because heaven's resources are infinite. All of God kingdom citizens are equal there are no have's and have note's.

CHAPTER 25

Seven Wonders of Heaven

First Wonder of Heaven is its **existence.**
One of the classic Christmas movies of all time is the movie Miracle on 34th Street.

And one of the most memorable lines from that move is, Yes Virginia there really is a Santa Claus. Well, I've come to tell somebody tonight, "Yes Virginia there really is a Heaven.

Historical Literature has given us many wonderful make believe lands such as
- The Land of Oz
- Never, Never Land
- Camelot
- Atlantis

These places have captured the imagination of readers for many generations. Heaven is not another land of Make Believe. There are over 400 references to Heaven in the Bible. Jesus Himself referenced to heaven when he taught His disciples how to pray when he said in Matthew 6:9 - Our Father who art in Heaven hallowed be your name. John 14:2-3

Second Wonder of Heaven: **Perfection** All the things that brings us so much sorrow and suffering in this imperfect world, will be gloriously absent in Heaven! **Rev** 21:3-4 - And God shall wipe away all tears from

their eyes. and there shall be no more death, neither sorrow, nor crying, neither shall there be any more pain; for the former things are passed away.

- No more strokes
- No more Alzheimer
- No more Ambulances
- No more Hospitals
- No more funeral processions

Third Wonder of Heaven: **Incredible size**
1,400 miles long, 1,400 miles wide, 1,400 miles high

(1)That means that there is nearly 2 MILLION SQUARE MILES just in the width and length of it! (2) If heaven were laid out in stories, and each story was 100 miles high, there would be 1,400 stories each of which would be 1,960,000 square miles!

- (a) By comparison, New York City is approximately 305 square miles in size.
- (b) There are approximately **8.4 million people** living in that **305 square-mile area.**1) This means that you could fit New York City and all its inhabitants inside **one level** of heaven approximately **6,500 times!**2) That is **54,600,000,000** [54 Billion, 600 Million] – PER LEVEL if there are multiple levels (and we KNOW that there are at least THREE levels! Surrounding this massive cube is a Wall 200feet thick!

The Fourth Wonder of Heaven is its incredible **Beauty.** 1. In verse 11 John describes the overall beauty of Heaven as being like jasper that is clear as crystal.a. The Greek word used for jasper in this verse refers to a completely clear diamond with the brilliant light of God's radiant glory shining out of it. 2. The foundation of Heaven is made of 12 precious gems. a. Because some of the names of these gems has changed through the centuries, it is difficult to identify all twelve as John saw them, but we can show them to you as they have been identified most recently (in alphabetical order)... Amethyst - Beryl - Chrysolite - Emerald - Sapphire - Sardius - red gem Topaz yellow

The Fifth Wonder of Heaven the wonder of Heaven's **Holiness** - No temple, no sun, no moon, no night, no closed gates. Nothing but the glorious presence.

Here on earth we close our gates, lock our doors and our windows because of all the unholy things that linger in the darkness. Because of Heaven's holiness there will be no night in heaven, and therefore there never be a need to shut Heaven's gates!

The sixth wonder of Heaven is the wonder of **who Won't be there.**
Nothing dirty or defiled will get into the city, and no one who defiles or deceives. Only those whose names are written in the Lamb's Book of Life will get in.

The seventh wonder of Heaven is the wonder of **who will be in Heaven.**
Rev 21:3 - Now the dwelling of God is with men, and He will live with them. They will be His people, and God Himself will be with them and be their God.

- Angels will be there
- Representative of the church 24 elders
- Christians from every nation will be there
- Love one and friends who have gone on before us

CHAPTER 26

Staying behind or Moving Forward"

Exodus 14:10-16

Country Singer Kenny Rogers wrote a song called "**The Gambler**" in it at the end it say - You got to know when to hold'em know when to fold 'em Know when to walk away and know when to run.

Some things in life you don't have to be a Rocket Scientific to understand just have plain common sense.

For 480 years, all Israel had known was bondage

- They had bread, but yet with bondage
- They had a place to stay but yet with captivity
- Clothing but with confinement
- existence, but with anguish
- life but no liberty

Israel was enslaved in Egypt persecuted by a Pharaoh who did not know Joseph but God remembered his covenant with Abraham and heard their cries. Exodus 2:23-25 - And it came to pass in process of time, that the king of Egypt died: and the children of Israel sighed by reason of the bondage, and they cried, and their cry came up unto God by reason of the bondage. 24 And God heard their groaning, and God remembered his covenant with Abraham, with Isaac, and with Jacob. 25 And God looked upon the children of Israel, and God had respect unto them.

God raised up Moses, hidden three months by his mother because Pharaoh was killing all the male babies. Being led by God she put him a little small basket onto the Nile river miraculously Moses is discovered by Pharaoh's daughter and upon the advice of Miriam Moses sister who had watched all this secures the nursing services of his own mother. Moses grows up in Pharaoh's court, but at the age o forty flees the land of Egypt.

Hebrew 11:24-26 - 24 By faith Moses, when he was come to years, refused to be called the son of Pharaoh's daughter; 25 Choosing rather to suffer affliction with the people of God, than to enjoy the pleasures of sin for a season; 26 Esteeming the reproach of Christ greater riches than the treasures in Egypt: for he had respect unto the recompence of the reward. 27 By faith he forsook Egypt, not fearing the wrath of the king: for he endured, as seeing him who is invisible. 28 Through faith he kept the passover, and the sprinkling of blood, lest he that destroyed the firstborn should touch them. 29 By faith they passed through the Red sea as by dry land: which the Egyptians assaying to do were drowned Moses first 40 years he is a prince in egypt, his second 40 years he receives his call at the burning bush, his third 40 years his lead the the children of Israel out of Egypt. He calls down the ten plagues upon Egypt.

Water into blood, frog invasion, lice, flies, cattle disease, boils, hail with fire, locus, three day darkness, death of firstborn.

Exodus represent leaving sin, Egypt represent staying in sin.

Anytime you are leaving a place of bondage and sin their will be challenges you will have to face.

Verses 11 - And they said unto Moses, because there were no graves in Egypt hast thou taken us away to die in the wilderness? Let us alone, that we may serve the Egyptians, for it had been better for us to serve the 7000 churches close their doors each year, 97% of Pastors been betrayed at some point or been falsely accused or hurt by their members!!!! 70% of Pastors battle with depression!!!! over a 1000 pastors quit and walk out on their calling each month!!!!! 90% of Pastors work in excess of 55 to 75 hours, not to mention a full time job and manage their family!!!!

Bishop Gregory Tucker

50% of Pastors marriages "FAIL" or come under severe attacks, leading to over 80% of them to "FEEL DISCOURAGED" SO WHEN YOU ARE SMILING IN YOUR LEADERS FACE EACH AND EVERY SUNDAY SHOUTING PRAISE THE LORD IN YOUR SUNDAYS BEST, YOUR COMING INTO AGREEMENT AND YOUR RESPONSIBILITY BECOMES THE MOST IMPORTANT AND THAT'S TO PRAY AND INTERCEDE FOR THE MAN OR WOMEN OF GOD!!!! than that we should die in the wilderness.

- 40% of American babies are born out of wedlock back in the 1960's it was only 5%
- Parent have to give consent for there child to take a aspirin in school but not when they have and abortion
- over 40 million condones was palled out in New York Schools last years
- Sandy hook elementary school 20 children and six adults lost there lives even more a tragedy when in America every year around 1.4 million abortions are carried out int the United States. 3000 abortions every single day, and one abortion every 20-23 seconds.
- Same sex marriage is allowed in Connecticut, Massachusetts, Vermont, Washington DC, New Hampshire, Lowa, and New York

Sin is a transgression of God laws. It separates us from God. Your iniquities have separated you from your God your sins have hidden His face from you so that He will not hear.

Just as a dark cloud in the sky blocks out light from the sun, so the light from the son of God is blocked out by our sin.

If someone falls into a deep hole in the ground, no matter how desperately he may work and struggle to climb out he is unsuccessful, but if a friend comes with a rope or long ladder he will be able to get out. Similarly, no matter how desperately we work or struggle we cannot free ourselves from the punishment and consequences of sin by our own efforts, we are helpless. We need the help of the Lord Jesus who has not fallen into sin to rescue us..

One week, the preacher preached on commitment, and how we should move forward into doing service for others. After this sermon, the song leader led the congregation in singing "I Shall Not Be Moved." The next Sunday, the preacher preached on giving and how we should gladly give to the work of the Lord. The song leader then led the song, "Jesus Paid It All." The next Sunday, the preacher preached on gossiping and how we should watch our tongues. The hymn was "I Love To Tell The Story." The preacher became disgusted over the situation and, the next Sunday, he told the congregation he was considering resigning. The congregation then sang "Oh, Why Not Tonight." When the preacher resigned the next week, he told the church that Jesus had led him there and Jesus was taking him away. The song leader then sang "What a Friend We Have in Jesus."
We as believers have at least three choices

1) We can make choice to do nothing to stay where we are
2) We can make the choice to go in reverse
3) We can make the choice to Move Forward

Every child of God will at one time or another face a Red Sea. Your Red Sea may be a lost of a Job.

- Family issues
- Sickness
- Lost of Job
- lack of finance

CHAPTER 27

"The Church that refused to Complain"

The Rev. Paul Jones composed the song "I Won't Complain"
I've had some good days
I've had some hills to climb
I've had some weary days
And some sleepless nights

When we as the Church of the Lord Jesus Christ stop complaining and start giving God the sacrifice of Praise, this will no only please God but help us also in the process.

The majority of believers in the Body of Christ has the wrong concept about suffering. Why do the righteous suffer? Job 2:10 - Shall we accept good from God, and not trouble.

Psalm 119:71 - It is good for me that I have been afflicted; that I might learn thy statutes. Before I was afflicted I went astray, but now I keep thy word.

God's uses Suffering To:

- Expose your sin - deter you from going astray and leads to obedience
- To build Your Character - produces steadfastness, endurance refine your character and renew your hope
- Produce much Good - Suffering gives you the opportunity to show care to others who suffer, equips you to comfort others.

- To Bless your future - Suffering with perseverance results in being blessed with the crown of life.

Many times we are not directly responsible for our suffering. In a sinful world both good and evil people will suffer. Matthew 5:45 - He sends rain on the righteous and unrighteous. As a Christian, you have a promise from God that your suffering here on earth will on day come to an end.

Job asked the question, Why did I not perish at birth and die as I came from the womb? But he later came to the realization that God was still there, still loved him, and was still providing for all his needs. He saw beyond his circumstances and grasped a new vision and insight into the fairness of God. Instead of questioning the goodness of God by asking, Why do good people suffer? he spent the rest of his life humbly trusting God.

Always Remember - Nothing that happens in this life will ever compare to the happiness and joy awaiting those who become children of God.

<u>God keeps a record of your grief and put your tears in His bottle.</u>
<u>Psalm 56:8 ESV - You have kept count of my tossings; put my tears in your bottle. Are they not in your book.</u>
<u>He encamps around you in the midst of trouble</u>
<u>Psalm 34:7 - The angel of the Lord encampeth round about them that fear him, and delivereth them.</u>
<u>He is near you when you are brokenhearted</u>

Psalm 34:18- The Lord is nigh unto them that are of a broken heart; and saveth such as be of a contrite spirit

CHAPTER 28

Learning The Easy Way To Pray

Don't you know the devil trembles when he sees the weakest saint on his knees. Prayer is like gasoline to a car. If the car has no gas it cannot run. To many christians are trying to run their spiritual cars on empty looking for God to work miracles in their lives.

Be honest with me, how many of you have run out of gas while driving your car. Imagine being stalled on the side of the road and someone stop and ask you what's the problem and you say something like I don't know what's the problem is, when you know quite well you ran out of gas.

To many of us are making excuses for our lack of communication with God. Therefore because of a lack of prayer individually and cooperatively the Body of Christ becomes powerless. Always remember a little prayer produces little power, but a whole lot of prayer produces a whole lot of power.

It is embarrassing when someone ask you to pray and you can't remember the Lord Prayer. Here you are stumbling over your words saying Our Father which art in Hell, Hallowed be thy son, thy kingdom don't come. Thy will be done in heaven as it is in earth. Give me this day our daily bread and forgive me my debts as I don't forgive others.

As believers when we don't pray, we develop a complaining spirit. We have no reverence for authority, call what is right wrong and what is wrong right.

I strongly believe our lack of prayer in the Body of Christ is due to the fact that we just don't know how to pray. I will show you a simple and easy way to pray everyday that will take you to another level in God.

By using your hand I will show you the most effective, simple and easy way to pray everyday.

The **Palm** of your hand represents **Repentance**. The palm is in the center of your hand meaning in order for God to receive or answer any of our prayer we must first ask for His forgiveness of all our sins and inquiries. Psalm 66:18 - If I regard iniquity in my heart, the Lord will not hear me. When we first receive Christ in our life we repented of all known sin and God forgave us. We must also remember after washing our dirty clothes and we put them on to wear again before the day is over they become dirty again. Therefore we must repent everyday of all known and unknown sin that we may havecommitted during the course of the day. Here are some examples of those who repented from scripture.

3000 people Repented- Acts 2:38-41- Then Peter said unto them, **Repent**, and be baptized every one of you in the name of Jesus Christ for the remission of sins, and ye shall receive the gift of the Holy Ghost. 39 For the promise is unto you, and to your children, and to all that are afar off, even as many as the Lord our God shall call. 40 And with many other words did he testify and exhort, saying, Save yourselves from this untoward generation. 141 Then they that gladly received his word were baptized: and the same day there were added unto them about three thousand souls

David - Psalm 51:1-3 -Have mercy upon me, O God, according to thy lovingkindness:

according unto the multitude of thy tender mercies blot out my transgressions. Wash me throughly from mine iniquity, and cleanse me from my sin for I acknowledge my transgressions: and my sin is ever before me.

Peter - Luke 22:61-62 - And the Lord turned, and looked upon Peter. And Peter remembered the word of the Lord, how he had said unto him, Before the cock crow, thou shalt deny me thrice. 62 And Peter went out, and wept bitterly.

Children of Israel - Judges 10:10 - And the children of Israel cried unto the Lord, saying, We have sinned against thee, both because we have forsaken our God, and also served Baalim.

The **Thumb** represents **Thanksgiving**. After Repentance comes Thanksgiving.

Psalms 100:3 - 4 Enter into his gates with thanksgiving, and into his courts with praise: be thankful unto him, and bless his name. For the Lord is good; his mercy is everlasting; and his truth endureth to all generations.

Thanksgiving is my response to the goodness, the graciousness of God.

Psalm 116:17 - I will offer to thee the sacrifice of thanksgiving, and will call upon the name of the Lord.

1 Thessalonians 5:16 - Rejoice evermore. 17 Pray without ceasing. 18 In every thing give thanks: for this is the will of God in Christ Jesus concerning you.

Thank God every day for at least one specific thing in the following areas of life and tell Him why you are thankful:

- Material Possessions - house, car, shoes, etc
- Physical blessing - eyes, mind, mouth etc.
- Spiritual blessings - forgiveness, prayer, joy etc
- People who has blessed you

The **Index finger** represents **Praise**. After thanksgiving comes Praise. Praise is my response to the person, presence, position, power, greatness, majesty and love of God. Psalm 145:3 - Great is the Lord, and greatly to be praised; and his greatness is unsearchable. 2

Seven Hebrew Words of Praise

- Towdah means to give God praise in spite of what you're going through - Hebrews 13:15
- Yadah is to raise and extend the hands unashamedly unto God - Psalms 134:2

- Barak is to kneel expectantly and quietly before God - Psalm 95:6
- Halal is to celebrate and rejoice in the Lord with a distinct sound - Psalm 22:22
- Zamar is to play a musical instrument unto the Lord - Psalm 33:2
- Tehillah is to sing unto the Lord - Psalm 40:3
- Shabach is to praise God with a shout for what he has done and going to do for you - Psalm 63:3

Thanksgiving and Praise can often be used together.
Thanksgiving and Praise can be expressed:

- in various ways: spoken, written, sung, played on an instrument
- by various moods: joy, contemplation, peace, wonder etc
- with various intensities: quietness, shouting, tenderness, excitement, strength etc
- with various body expressions: raised hands, clapping, kneeling, prostrate etc

The **Middle Finger** represents **Worship**. After thanksgiving and praise come **Worship**.

Worship is the highest form of praise. Going beyond the thoughts of all of His Wonderful blessings to us, we are expressing our admiration and commending God Himself for His person, character, attributes and perfection.

Worship is:

- To express reverence
- To have a sense of awe
- To bow low before the object of worship
- To esteem the worth of
- To give place to

John 4:24 - 24 God is a Spirit: and they that worship him must worship him in spirit and in truth.

Genesis 22:5 - And Abraham said unto his young men, Abide ye here with the ass; and I and the lad will go yonder and worship, and come again to you.

Roman 12:1-2 - 1 I beseech you therefore, brethren, by the mercies of God, that ye present your bodies a living sacrifice, holy, acceptable unto God, which is your reasonable service. 2 And be not conformed to this world: but be ye transformed by the renewing of your mind, that ye may prove what is that good, and acceptable, and perfect, will of God. True worship means that there has been a complete surrender of one's whole self to God.

The **Ring Finger** represents I**ntercession**. After Worship comes Intercession.

Intercession is prayer that pleads with God for the needs of others. It involves taking hold of God's will and refusing to let go until His will comes to pass.

Intercession is the key to God's battle plan for our lives. But the battleground is not of this earth. The Bible says, we are not fighting against humans. We are flighting against forces and authorities and against rulers of darkness and spiritual powers in the heavens above. Ephesians 6:12 - For we wrestle not against flesh and blood, but against principalities, against powers, against the rulers of the darkness of this world, against spiritual wickedness in high places.

Throughout the Bible, God searched for those willing to flight the spiritual battle for their land. In Ezekiel 22:30 - And I searched for a man among them who should build up the wall and stand in the gap before Me for the land, that I should not destroy it, but I found no one.

Abraham Interceded For **Sodom** and **Gomorrah** - Genesis 18:20-32
23 And Abraham drew near, and said, Wilt thou also destroy the righteous with the wicked? 24 Peradventure there be fifty righteous within the city: wilt thou also destroy and not spare the place for the fifty righteous that are therein? 25 That be far from thee to do after this manner, to slay the righteous with the wicked: and that the righteous should be as the wicked, that be far from thee: Shall not the Judge of all the earth do right? 26 And the Lord said, If I find in Sodom fifty righteous within the city, then I will

spare all the place for their sakes. 27 And Abraham answered and said, Behold now, I have taken upon me to speak unto the Lord, which am but dust and ashes: 28 Peradventure there shall lack five of the fifty righteous: wilt thou destroy all the city for lack of five? And he said, If I find there forty and five, I will not destroy it. 29 And he spake unto him yet again, and said, Peradventure there shall be forty found there. And he said, I will not do it for forty's sake. 30 And he said unto him, Oh let not the Lord be angry, and I will speak: Peradventure there shall thirty be found there. And he said, I will not do it, if I find thirty there. 31 And he said, Behold now, I have taken upon me to speak unto the Lord: Peradventure there shall be twenty found there. And he said, I will not destroy it for twenty's sake. 32 And he said, Oh let not the Lord be angry, and I will speak yet but this once: Peradventure ten shall be found there. And he said, I will not destroy it for ten's sake.

Moses Interceded For **Israel** - Exodus 32:11-13
And Moses besought the Lord his God, and said, LORD, why doth thy wrath wax hot against thy people, which thou hast brought forth out of the land of Egypt with great power, and with a mighty hand? 12 Wherefore should the Egyptians speak, and say, For mischief did he bring them out, to slay them in the mountains, and to consume them from the face of the earth? Turn from thy fierce wrath, and repent of this evil against thy people. 13 Remember Abraham, Isaac, and Israel, thy servants, to whom thou swarest by thine own self, and saidst unto them, I will multiply your seed as the stars of heaven, and all this land that I have spoken of will I give unto your seed, and they shall inherit it for ever.

Jesus Intercedes for His **Followers** - John 17:6-26
I have manifested thy name unto the men which thou gavest me out of the world: thine they were, and thou gavest them me; and they have kept thy word. 7 Now they have known that all things whatsoever thou hast given me are of thee. 8 For I have given unto them the words which thou gavest me; and they have received them, and have known surely that I came out from thee, and they have believed that thou didst send me. 9 I pray for them: I pray not for the world, but for them which thou hast given me;

for they are thine. 10 And all mine are thine, and thine are mine; and I am glorified in them.

God is calling Christians to join His battle plan for this world - to join in intercessory prayer. He is not looking for perfect warriors, just willing hearts who want to see His will come to pass on the earth.

We must plead with God to:

- Turn aside His Judgement - Gen:18:23-32
- Restore His people - Nehemiah chapter 1
- Deliver individuals from danger - Acts 12:5-12
- For the power of Holy Spirit to be manifested more - Acts 8:15-17
- For Christian Growth - Philippians 1:9-11
- For Salvation Roman 10:1/Acts 2:38

The **Baby Finger** represent **Petition prayers** for yourself.
Philippians 4:6 - Be careful for nothing; but in every thing by prayer and supplication with thanksgiving let your requests be made known unto God. 7 And the peace of God, which passeth all understanding, shall keep your hearts and minds through Christ Jesus.

If there are any problems in your life that seems insurmountable, that appears to be impossible to turn around now you can give it to Jesus. A petition prayer, simply put, is a formal request to God regarding a situation you need help with.

1 Peter 5:7 - Casting all your care upon him; for he careth for you. 5

Psalms 55:22 - Cast thy burden upon the Lord, and he shall sustain thee: he shall never suffer the righteous to be moved.

Prayers of petition are the type of prayer we are most familiar with. In them, we ask god for things we need, primarily spiritual needs, but physical ones as well. Our prayer of petition should always include a statement of our willingness to accept God's will, whether He directly answers our prayer or not. The Our Father is a good example of a prayer of petition,

and the line "Thy will be done" shows that, in the end we acknowledge that God's plans for us are more important than what we desire.

Praying for yourself offers several benefits. First of all praying for yourself can boost your self esteem as you focus on your own needs, values, and concerns. Many people struggle with not having enough time with themselves, and that trickles into their relationship with God, too. Taking time to check in every day with God helps build a deeper, most trusting relationship that can be the foundation for a happier, healthier life.

Checking in every day about what you need and what you seek can keep you grounded and better equip you in relationships with others, too. Giving to others from a place of personal emptiness can fuel resentment, anger, and passive aggression. Giving to others from a place of openness can be transformative in asserting boundaries, connecting with others, and being more sensitive to their needs because you are meeting your own.

The Easy Way to Pray is to look at your hand Remember the palm of your hand represents repentance so start out asking God to forgive you of all your sins. It doesn't matter how long you pray in each period. You can pray ten minutes or 30 minutes it up to you and the leading of the Holy Spirit. Next you began to give God thanks and praise.

Thanksgiving and Praise represent your thump and index finger. Then Worship began with the middle finger. Refuse to say a word during this section let God talk to you.

Next the ring finger is the intercession you will begin to pray for others as the Spirit leads. Last but not least, your pinky finger, pray for yourself and cast all of your cares, worries upon the King of Kings and the Lord of Lord's.

CHAPTER 29

The Law of Sowing and Reaping

Is God Divine Principle and foundational law of life.

Genesis 8:22 - While the earth remain, seedtime and harvest, and cold and heat, and summer and winter, and day and night shall not cease.

Galatians 6:7-9 - Be not deceived; God is not mocked: for whatsoever a man sow, that shall he also reap. 8 For he that sow to his flesh shall of the flesh reap corruption; but he that sow to the Spirit shall of the Spirit reap life everlasting.

God governs the universe through laws laws He set up before humans appeared on the horizon. It is not enough to know Jesus; you must understand the way He operates his kingdom

1. You will reap what you sow.
2. You reap that same kind that you sow.
3. You reap more that you sow and
4. You reap in a different season than what you sow.

Hosea 10:12 - 12 Sow to yourselves in righteousness, reap in mercy; break up your fallow ground: for it is time to seek the Lord, till he come and rain righteousness upon you. 13 Ye have plowed wickedness, ye have reaped

iniquity; ye have eaten the fruit of lies: because thou didst trust in thy way, in the multitude of thy mighty men.

We see two kinds of seed, good and bad, the flesh and the spirit.

Everybody is sowing, everybody is putting seeds in the ground, every body going to reap.

Years ago the top disciplinary problems in schools were **talking in class, chewing gum,** making noises, running in the halls; now the top disciplinary problems are **rape; robbery, assault, burglary, arson, bombing and murder.** We have gone from bad to worst.

When Rosie O'Donnell every morning on the View talked about her Lesbian life style as something to be glorified

Today America is flooded with books, movies, and TV series glorifying lesbianism, group sex, and wife swapping.

CHAPTER 30

"The Promise Keeper"/ "He Never Failed me Yet"

Have you ever known people who never keep a promise. They may promise you one thing and does something else; or never does anything at all. In the novel of "Mice and Men" George promise Lenny that one day they would own their own farm and that Lenny would be able to have as many rabbits as he wants. But George ended up having to kill Lenny instead. The Bible mention that the **Arm of Flesh** will fail you. That means that man in all of his wisdom and ingenuity, technology, and might is still subject to failure.

2 Chronicles 32:7-8 - Be strong and courageous, be not afraid nor dismayed for the king of Assyria, nor for all the multitude that is with him: for there be more with us than with him: 8 With him is an arm of flesh; but with us is the Lord our God to help us, and to fight our battles. And the people rested themselves upon the words of Hezekiah king of Judah.

In the dreadful morning of April 15, 1912 the Titanic ship they said that God could't sink hit an iceberg in the North Atlantic and 1,500 people lost their lives in the disaster. The name titanic means enormous size, strength, power.

Every Politician knows that the key to winning elections is to make great promises. Campaigners promise to cure the ills of society including taxes, war, government corruption, and pollution.

George HW Bush promised no new taxes during his 1988 campaign and then raised taxes when he got into office. Read my lips no more taxes.

Married couples failed to keep their promises made doing the wedding ceremony. The preacher tells the Groom to repeat after him I John Doe take thee, Mary Jane to be my lawful wedded wife, to have and to hold from this day forward, for better for worse, for richer for poorer, sickness and in health, to love and to cherish, till death us do part.

Bride: I Mary Jane take thee, John Doe to be my lawful wedded Husband to have and to hold from this day forward, for better for worse, for richer for poor, in sickness and in health, to love, cherish, and to obey till death us do part.

Something before the Honeymoon start the vows are broken.

Napoleon Bonaparte was quoted saying, the best way to keep one's word is not to give it.

Abraham Lincoln - We must not promise what we ought not, lest we be called on to perform what we cannot.

For every promise, there is a price to pay - Jim Rohn

But you can rest assure that when God makes a promise it will be fulfilled no matter what. 2 Cor 1:20 For all the promise of God are yea and in him Amen. Yea means even so surely and truth, Amen mean I confirm that what was said is true. God Amen's himself in other words He stand behind his own word.

Titus 1:2 - 2 In hope of eternal life, which God, that cannot lie, promised before the world began;

Hebrews 6:18 - 18 That by two immutable things, in which it was impossible for God to lie, we might have a strong consolation, who have fled for refuge to lay hold upon the hope set before us.

Numbers 23:19 -19 God is not a man, that he should lie; neither the son of man, that he should repent: hath he said, and shall he not do it? or hath he spoken, and shall he not make it good.

Roman 4:21 - And being fully persuaded that what he had promised He was able to perform.

2 Peter 3:9 - The Lord is not slack concerning his promise, as some men count slackness; but is longsuffering to us- ward, not willing that any should perish, but that all should come to repentance.

When God gave a command he says You Will but when God gives a promise he say "I Will"

Unconditional Promise

Never be another flood to destroy the earth - Gen 9:8-17

Not to curse the ground anymore for man's sake - Gen 8:20-22-And Noah builded an altar unto the Lord; and took of every clean beast, and of every clean fowl, and offered burnt offerings on the altar. 21 And the Lord smelled a sweet savour; and the LORD said in his heart, I will not again curse the ground any more for man's sake.

Resurrection of all the dead - John 5:28,29 - 28 Marvel not at this: for the hour is coming, in the which all that are in the graves shall hear his voice, 29 And shall come forth; they that have done good, unto the resurrection of life; and they that have done evil, unto the resurrection of damnation

Purify the earth with fire - 2 Peter 3:10-12 -But the day of the Lord will come as a thief in the night; in the which the heavens shall pass away with a great noise, and the elements shall melt with fervent heat, the earth also and the works that are therein shall be burned up. 11 Seeing then that all these things shall be dissolved, what manner of persons ought ye to be in all holy conversation and godliness, 12 Looking for and hasting unto

the coming of the day of God, wherein the heavens being on fire shall be dissolved, and the elements shall melt with fervent heat.

Conditional Promise of God

Psalms 84:11 - 11 For the Lord God is a sun and shield: the LORD will give grace and glory: no good thing will he withhold from them that walk uprightly.

2 Chronicles 7:14 - If my people, which are called by my name, shall humble themselves, and pray, and seek my face, and turn from their wicked ways; then will I hear from heaven, and will forgive their sin, and will heal their land.

Roman 10:9 -9 That if thou shalt confess with thy mouth the Lord Jesus, and shalt believe in thine heart that God hath raised him from the dead, thou shalt be saved.

Acts 2:38-39 - 38 Then Peter said unto them, Repent, and be baptized every one of you in the name of Jesus Christ for the remission of sins, and ye shall receive the gift of the Holy Ghost. 39 For the promise is unto you, and to your children, and to all that are afar off, even as many as the Lord our God shall call.

CHAPTER 31

John 14:1-6 - The Way Truth and the Life

I am the Way: The sin of Adam in the Garden of Eden caused mankind to be lost.
Have anyone here be traveling on the highway and somehow you made a wrong turn and got lost. Well Adam made a wrong turn when he ate from the tree of knowledge of good and evil. Roman 5:12 - **Wherefore, as by one man sin entered into the world, and death by sin; and so death passed upon all men, for that all have sinned.**

It only take one wrong move to lose a game
It only take one phone call to miss up your day
It only take one bad decision to cause you to end up in jail
It only take one argument to miss up your marriage
It only take one sin to miss heaven Matthew 12:31 - Therefore I say unto you all manner of sin and blasphemy shall be forgiven unto men: but blasphemy against the Holy Spirit shall not be forgiven unto men.

Just one sin caused mankind to be lost.
But Jesus said I am the Way.
I am the way out of sin.
I am the way to bring you back to God
I am the way of to your happiness and success
I am your way out of trouble

1 Corinthians 15:45 - The first man Adam was made a living soul; the last Adam was made a quickening spirit

Jesus death on the cross brought mankind back to God. In other words I was lost but now I am founded. Acts 4:12 - Neither is there salvation in any other: for there is none other name under heaven given among men, whereby we must be saved.

Matthew 1:21 - And she shall bring forth a son, and thou shalt call his name Jesus for he shall save his people from their sins.

I am the Truth: In other words I cannot lie. Whatever I say or said you can trust in it.

Number 23:19 - God is not a man, that he should lie; neither the son of man, that he should repent: hath he said, and shall he not do it? or hath he spoken, and shall he not make it good.

Hebrews 6:18 - 18 That by two immutable things, in which it was impossible for God to lie.

I am the Life: John 10:10 - The thief comes not but for to steal, and to kill and to destroy: I am come that they might have life and that they might have it more abundantly.

Greek Word Zoe - eternal life

John 3:14 - As Moses lifted up the serpent in the wilderness even so must the Son of Man be lifted up.

Hebrew 9:27 - And as it is appointed unto men once to die, but after this the judgment.

I am your way out of no way
I am the truth the whole truth and nothing but the truth
I am life in the midst of death.

Jesus said Matthew 11:28 - Come unto me, all ye that labour and are heavy laden, and I will give you rest.

Take my yoke upon you and learn of me; for I am meek and lowly in heart: and ye shall find rest unto your souls. For my Yoke is easy and my burden is light.

Bishop Gregory Tucker

When Need the Lord Jesus Christ when:
Decline of the Traditional Family
1 out of 2 american high school students in major cities even graduates
1 out of every 4 teenage girls has at least one sexual transmitted disease
One out of every 10 americans is now on food stamps
Every year there are nearly 12 million crimes committed in the U.S.
Over 600,000 americans are trading dirty child pictures online
There are 400,000 registered sex offenders
Significant levels of both pharmaceutical drugs and illegal drugs in our water supplies despite rigorous efforts to remove them at water treatment facilities.
Around 50 million abortions has occurred since Roe Vs Wade

CHAPTER 32

To Die Is Gain

Philippians 1:21 - For to me to live is Christ and to die is gain.
When the Apostle Paul wrote this letter to the church at Phiillipi, the circumstances of his life weren't exactly ideal. He was in prison-under house arrest in Rome-chained to a Roman soldier as his his guard. Paul was a prisoner and yet this entire letter shouts with triumph. It is filled with the words "Joy" and "rejoicing".

Right Christian experience is the outworking of the life and mind of Christ in our lives whatever our circumstances might be.

To those who do not believe in God-Life on earth is the best there is. For the non Christian, it is only natural to strive for the world's values. Money, Popularity, Power - Prestige.
For the Christian it is different. "To die is gain"
What do we gain when we die?

- A. **We Gain a better body** - A glorified, immortalized, resurrected body.

 In this present body of clay we are subject to all the sorrows and tears that life is heir to. Age, sickness, and finally death are the inevitable end of this house made of the dust of the earth. But in death and the resurrection we gain a better body, one that can never grow old, know disease, suffer pain, and can never die. We gain a better body.

B. **<u>We gain a better home.</u>**
However the beauty and the embellishments of any house we may possess in this world, it is nothing compared with our mansion in the beautiful city of God. John 14:1-3

C. **<u>We Gain a better Inheritance</u>**
Our final reward is not here -It is in Heaven

D. **<u>We Gain a better fellowship</u>**

4. We Gain a better fellowship.
All of us live in this world of a dissolving family circle. Mother is gone – Father is gone, or a child is gone, or our beloved grandparents are gone, or a close friend is gone. But the circle is unbroken in Heaven forever and ever. There is no death there, no sorrow or crying or pain, for these former things are passed away.

Jesus is there.
5. If "for me to live is Christ," then to die is gain.
If for me to live is money – then to die is loss.
If for me to live is self – then to die is loss.
If for me to live is ambition – then to die is loss.

CHAPTER 33

"The Power of Friendship"

<u>Ecclesiastes</u> 4:9-12

9 Two are better than one; because they have a good reward for their labour. 10 For if they fall, the one will lift up his fellow: but woe to him that is alone when he falleth; for he hath not another to help him up. 11 Again, if two lie together, then they have heat: but how can one be warm alone? 12 And if one prevail against him, two shall withstand him; and a threefold cord is not quickly broken.

Solomon writes this book as a review of life. He is considering those things in life that are lasting value, and those things that are passing, empty, or vain. He lists many things that are vain. He lists pleasures, money, fame, and many other things that in the end are empty and void of lasting value and meaning. Among those things Solomon listed as having lasting value and benefit was **<u>friendship.</u>**

I first meet Jerome in the first grade at **<u>Chew Haw Elementary School.</u>** It was a small school with dedicated teachers that loved and cared for their students. Jerome and I would always compete with each other in math. Of course he would end up with the higher score. When Chew Haw School burned down we were sent to **<u>Washington Public</u>** then **<u>Lewis Adams</u>** then **<u>Tuskegee Institute High School</u>**.

Jerome introduced me to game of ping pong and pool; he encouraged me to join the **ROTC drill team**. We won second prize in Fort Benning Ga drill team competition.

Jerome was considered the city. You see he lived in Tuskegee. We were considered country. We lived in Notasulga. However he did not consider it robbery or belittering to hang out with us country boys. He became one of our best friends.

We are living in a day where real friends are very hard to find. Jerome I can says and many would agree with me today was the best friend anyone could every have. He treated people the way he wanted to be treated. Jerome would go out of his way to help someone. He help organized and fund our class reunions. Jerome name is of Latin origin meaning "**Holy Name" Sacred**.

J - Joyful to be around
E - Example for others to follow
R - Real - Spoke whatever was on his mind
O - Out-think (to think deeper, faster)
M - Motivating
E - Encouraging

Friendship is a powerful aspect of the human existence. In America we are moving toward social isolation. We can work out of home offices, shop on line and have the goods delivered to our door. We can bank on-line and get our entertainment on cable. And yet we are loosing social skills while there are so many people feeling isolated, frustrated lonely and empty.

A Newspaper in England was giving out a reward to anyone who could give the best definition of what is a friend? (Thousands answered) The best definition that was chosen was "A Friend is one that comes when everyone else goes" That was Jerome.

ILLUSTRATION: A young boy was sent to the corner store by his mother to buy a loaf of bread. He was gone much longer than it should have taken

him. When he finally returned, his mother asked, "Where have you been? I've been worried sick about you."
"Well," he answered, "there was a little boy with a broken bike who was crying. So I stopped to help him."
"I didn't know you knew anything about fixing bikes," his mother said.
"I don't," he replied. "I just stayed there and cried with him."

It takes three ships to complete the **journey of Life**: **Companionship, Kinship** and **friendship.** Jerome had completed all three. When he married Linda His soul mate, joy of his life, high school sweet heart. **Kinship** his three beautiful daughter sister Yronne and brother Alvin and many other relatives. Friendship all the rest of us who's lives has touched by him.

What is a friend? A friend is someone who can rejoice with you in your victories. A friend is someone who can celebrate your triumphs with you and you know that they are not jealous, but genuinely happy.

Proverbs 18:24 - A man that hath friends must show himself friendly: and there is a friend that sticks closer the a brother.
Proverbs 27:17 - Iron sharpens iron, so does a man sharpen the countenance of his Friend. As iron sharpens iron, a friend sharpens a friend.
Proverbs 27:6 - Faithful are the wounds of a friend, but deceitful are the kisses of an enemy.

God created us with this unbelievable ability to impact one another. We depend upon one another for survival, sustenance and well being. In science a lone atom is meaningless but related atoms or a chain of atoms makes up a molecule. This is the building block of nature.

So we have all come together to celebrate the life of our friend. We lift up Jesus because we know if it had been for him dying on the cross none of us would be here.

What a Friend we have in Jesus, all our sins and griefs to bear! What a privilege to carry everything to God in prayer!

CHAPTER 34

Building Strong Saints

Ephesians 6:10 - Finally my brethren be **Strong** in the Lord and in the power of His Might.
Daniel 11:32b - But the people that do know their God shall be **strong** and do exploits.
Three of the most important things a Pastor and congregation can give to each other that cause them to grow is **acceptance, support**, and **respect.** Our acceptance support and respect of each other are essential to the **emotional, social,** and **intellectual growth** of a Pastor and congregation.
Accept me for who I am, realizing that we are all different.
Support Me - Courage me say words the build me up
Respect Me - Don't talk about my weakness to others.

Last week we dealth with the S in strong today i would like to deal with the T in the word strong. T in strong represent Trust.

Our God longs for us to be completely dependent upon Him and to have utter confidence in Him. **1 John 5:14 -** And this is the **confidence** that we have in him, that if we ask any thing according to his will he hears us. And if we know that he hears us, whatsoever we ask, we know that we have the petitions that we desired of him.

Hebrews 6:18 - That by two immutable (unchangeable) things, (Promise and Oath) in which it was impossible for God to lie, we might have a strong consolation, who have fled for refuge to lay hold upon the hope set before

us: Because He has spoken His Word, He has given the promise of eternal life and double assurance by swearing upon himself.

Trust does not come from the head but from the heart. It is not a result of reasoning; it is the result of believing. Roman 4:3 - Abraham believed God and it was counted unto him for righteousness.

We live in a stressful world only our trust in God can elective some of the negative stress. Four main causes of stress.

We read in our daily newspapers or see on the evening news instances of grief, heartache, and pain on a massive scale. 1)Tramatic Events such as War, terrorism, earthquakes, famine, racial injustice, murder and exploitation occur daily in various parts of the world. The threat of a nuclear holocaust hanging over our heads has caused this period of history to be called the age of anxiety.

2. Conflict - Family conflict - Your son or daughter have married someone of the same sex. Bills are paling up and you don't know what to do. Baby needs a pair of shoes, telephone disconnect

3. Life changes - Unemployment After turning fifty you wake up in the morning you back start hurting, you go to the dentist he tell you that you have a gum disease and all your teeth must be replace with false teeth.

4. Daily Hassles - You driving along and the car in front of you stopped because of the traffic and the person behind you is blowing there hung as loud as they can at you to move. (tell your story)

The Bible says this about trusting God, "Trust in the LORD with all your heart and lean not on your own understanding" (Proverbs 3:5). Furthermore, it tells us that "He who trusts in himself is a fool..." (Proverbs 28:26). Still, most of us have difficulty trusting God at least at one point or another in our walk with Him.

But we can't trust someone we don't know and there is only one way to know God—through His Word. There is no magic formula to make us

spiritual giants overnight, no mystical prayer to pray three times a day to mature us, build our faith and make us towers of strength and confidence. There is only the Bible, the single source of power that will change our lives from the inside out. But it takes effort, diligent, everyday effort to know the God who controls everything. If we drink deeply of His Word and let it fill our minds and hearts, the sovereignty of God will become clear to us, and we will rejoice in it because we will know intimately and trust completely the God who controls all things for His perfect purpose.

Sometimes God allows challenges into our lives to build a better person (character development), lets take for instance if you don't possess patience God will send a situation(s) to help you acquire patience, if you don't have faith, God will send situations that will require you to have faith.

So never look at a difficult situation as a curse, look at it as a blessing, as a test, as being in a classroom. God is depending on you to pass this test to ascend into another level.

Ecclesiastes 7:13 - Consider the work of God for who can make that straight which he hath made crooked?

Psalm 78:19-22 -19 Yea, they spake against God; they said, Can God furnish a table in the wilderness?

20 Behold, he smote the rock, that the waters gushed out, and the streams overflowed; can he give bread also? can he provide flesh for his people?
21 Therefore the Lord heard this, and was wroth: so a fire was kindled against Jacob, and anger also came up against Israel
22 Because they believed not in God, and **trusted not in his salvation**

In order to trust God, we must always view our adverse circumstances through the eyes of faith, not of sense. Faith to trust God in adversity comes through the Word of God alone. It is only in the Scriptures that we find an adequate view of God's relationship to and involvement in our painful circumstances.

CHAPTER 35

Trying of your Faith

Roman 15:4 - For whatsoever things were written aforetime were written for our learning, that we through <u>patience</u> and <u>comfort of</u> the scriptures might have hope.

James 1:2-3 - My brethren, count it all joy when ye fall into divers temptations; Knowing this, that the <u>trying of your faith</u> works patience. But let patience have her perfect work, that ye may be perfect and entire, wanting nothing.

We've all discovered that life is tough, but God uses tough tests throughout our lives to stretch our faith. God wants us to pass these tests, so he's already provided the answers in the Bible, which he gave us for the encouragement that Roams 15:4 describes above. Every problem has a purpose, and God can bring good out of every bad.

1. Faith Is Believing When I Don't See It
God build your character through tests. Either your coming out of a test, in the middle of a test, or getting ready to go into one. Life is a simply a series of tests. Big tests, little tests, long tests. short test, major tests, minor tests.

We see that God always starts by giving people an **opportunity,** then there is an **obstacle or opposition,** then there is an **ordeal.** If you **resist the opposition** and you **pass the ordeal,** you **get the opportunity.**

In the case of Noah the opportunity God said, I am going to use you to **save the entire world.** After the opportunity comes the obstacle or the opposition.

The obstacle in Noah's life is nobody believed him. When God said, I am going to use you to build an ark, Noah said, What an ark? Because nobody had ever seen one. Nobody had ever seen a flood nor rain. The atmosphere changed after the global flood.

2. **Faith is Obeying When I Don't Understand it**
Abraham, God had said to Abraham, "**You're going to be the father of a great nation.**" The problem was at age ninety-nine Abraham still had no children and his wife was ninety. That's a problem, folks! That's a major obstacle if you're waiting to get pregnant. Big problem there.

3. **Faith is Persisting When I Don't Feel Like it**
Moses opportunity **I am going to use you to set the people free.** Moses had an obstacle of opposition. He had to fight the most powerful man in the world who was Pharaoh, the ruler of Egypt. Egypt was the largest empire; it dominated the world in its day. Moses was going up against the most powerful man in the world to release the Hebrew slaves.

So all three of them had opposition.
Then the third stage was an ordeal. **An ordeal happens in your life when there's a delay between what God tells you what he's going to do and him actually doing it in your life.** There's always a waiting period. There's always a delay. When God tells you what he's going to do, gives you a dream, there's always a delay.

Noah's life, the delay took 120 years
Abraham delay took 25 years. Give at age 75 fullified 25 years later.
Moses Then Moses spends forty years in the wilderness tending sheep after being kicked out of Pharaoh's court. Then he spent another forty years taking the children of Israel across the desert to the Promised Land of Israel.

First Test - Impossible Task
Second Test - A Major Change
Three test - Delayed Promise
Fourth Test - Senseless Tragedy Test

CHAPTER 36

"What you need God Got It"

Jeremiah 8:22 -22 Is there no balm in Gilead; is there no physician there? why then is not the health of the daughter of my people recovered.

A balm is a healing ointment. Jeremiah is asking about the famous healing lotion made from the a tree in Palestine, the **resinous gum we know as Myrrh**. Jeremiah is a making s spiritual reference to the healing power of God. In the New Testament baby Jesus will be give this balm to show healing does exist with him.

The Balm of Gilead is interpreted as a spiritual medicine that is able to heal Israel and sinners in general.

Before 1865, African American spirituals and slave songs were sung throughout the south. These songs told the gospel and converted scripture to people who couldn't read, and were used for everything from teaching English and counting to new arrivals to keeping time in a threshing house, to communicating news about the underground railroad. Song like THIS TRAIN IS BOUND FOR GLORY, AND SWING LOW, SWEET CHARIOT were both underground railroad songs. One of the great old hymns to come out of the era was :There is a Balm in Gilead. An oppressed people who like Israel, had been captured, enslaved, and ill used were answering Jeremiah's question with a song.

Sometimes I feel discouraged and think my work's in vain, But then the Holy Spirit revives my soul again. There is a balm in Gilead to make the wounded whole; There is a balm in Gilead to heal the sin sick soul.

In order to receive your healing, we must have what I call **Focus Faith.**

Corrie Ten Boom who suffered in a Nazi death camp, explained the Power of Focus. She said If you look at the world you'll be **distressed.** If you look within you'll be **depressed**. But if you look at Christ You'll be at **Rest.**

If you focus of Jesus He will use your problems to fulfill his purposes in your life.

Question: What's one thing does all miracle have in common. Some say in order to have a miracle you must have faith, other say you must pray in order to receive a miracle. But some people in the Word of God didn't have faith and didn't pray and received a miracle. One thing that all miracle have in common is a problem

In order to receive a miracle you must have a problem. So if you have a problem you can receive a Miracle. Ask you neighbors do they have a problem if you do you are next in line for a miracle.

Philippians 4:19 - But my God shall supply all your need according to his riches in glory by Christ Jesus

Psalms 20:7 Some trust in **chariots,** and some in **horses:** but we will remember the name of the Lord our God

Isaiah 31:1 - Woe to them that go down to Egypt for help; and stay on horses, and trust in chariots, because they are many and in horsemen, because they are very strong but they look not unto the Holy One of Israel, neither seek the Lord!

CHAPTER 37

When Men Step Up To The Plate

Gen 1:26 - Let us make man in our image, according to our likeness, let them have dominion.

After creating the universe and the planet on which we live, He handed leadership of the earth over to humankind. Your and I were created to lead and to rule.

Everything rises and falls on leadership. Leadership of any group or organization will determine its success or failure. When God's people had a good king all was well with the nation. When they had a bad king, things went poorly for everyone. When God decided to raise up a nation of His own, He didn't call upon the masses. He called out one leader Abraham. When he wanted to deliver His people out of Egypt, He didn't guide them as a group. He raised up a leader to do it Moses. When it came time for the people to cross into the Promised Land, they followed one man Joshua. Every time God desires to do something great He calls a leader to step forward. Today He still calls elders to step forward for every great work.

- Being made in God's image means we were created to lead
- God commanded both male and female to have dominion
- We are to rule over the earth but not necessarily over each other
- All of us are to serve one another in the areas of our gifting and purpose
- Each person's leadership is best exercised in his or her area of giftedness - When we discover our gifts we will naturally lead in

those areas where we are most productive, intuitive, comfortable, influential, and satisfied.
- Matthew 16:19 - 19 And I will give unto thee the keys of the kingdom of heaven: and whatsoever thou shalt bind on earth shall be bound in heaven: and whatsoever thou shalt loose on earth shall be loosed in heaven.

Ezekiel 22:30 - And I sought for a man among them, that should make up the hedge, and stand in the gap before me for the land, that I should not destroy it: but I found none. 31

Marriage is the glue that keeps dads connected to their children. Illegitimate births and divorce are the two greatest factors that steal kids away from their fathers.

Couples in previous generations were more likely to stay together for the sake of the kids. But this generation has been increasingly convinced that kids are better off if their unhappy parents get a divorce. The stats reveal that this is not true. The absolute best thing for kids is to see their parents humble themselves, repent of their selfishness, forgive one another, and recommit to their marriage. The convenience of no-fault divorce has come at an extremely high price. And millions of innocent kids are forced to pay that price every year.

Instead of growing up, getting married, and courageously raising up the next generation, millions of young men are staying single, remaining emotionally and directionally dependent on their mothers while becoming addicted to entertainment, pornography, and video games. They want the privileges and rewards of manhood but only the responsibilities and moral requirements of boys. So when they become fathers themselves, they don't know what to do, and they feel extremely ill-equipped.

In generation past we looked up to men like Dr. Edward H. Boyce, my father in the Thomas P. Bulter, Nelson Mandela but today our young men are looking up to Pee Diddy, Jay Z, Nate Dogg, Dr. Dre, Eminem, Q-Tip Slick Rick.

Bishop Gregory Tucker

Young women, likewise, are entering life without a deep sense of value and worth. Rather than displaying feminine charm, modesty, and grace, many have become nearly (if not equally) as rude and unrestrained as the stereotypical guy. They are told to act like and outdo men as much as possible. Flirty, immodest, and aggressive, they stay on a constant search for acceptance and attention— things they haven't been freely given by the one man in their life whose love and approval they really want. And so millions of teenage girls auction away their priceless virginity every year for a pizza, a movie, and some on-the-spot flattery. Each of them hopes that being held for a few minutes by a porn-addicted teenage boy with raging hormones will somehow fill the dark canyon of love that her disengaged father has left aching inside her heart. And it never does.

When men step up to the plate:

- Homes are restored, lives are changed, and God is glorified.
- People are brought out of despair into delight
- Out of corruption and into Christ
- Out of shame and into Glory
- Out of perplexity and into Peace
- Out of foolishness and into truth
- Out of guilt and into forgiveness
- Out of misery and into comfort
- Out of failure and into success
- Out of grief and into gladness
- Out of hell and into Heaven

Step up to the plate brother and become:
Bible teaching men
Bible preaching Men
Praying Men
God called men
God committed men

A black preacher by the name of St. Augustine once said back in 350ad

Without God we cannot. Without us, God will not. God has intricately bound up His work in the lives of His people. We can quench His Spirit, we can grieve His Spirit, we an resist His Spirit. But God is still searching…. searching for who will Step up to the plate.

One of the World's Greatest Evangelist Johnny James Quotes
The Bible is the world greatest Book.
Jesus is the world's greatest Person
The Birth of Jesus the world greatest Birth
The Life of Jesus the world greatest Life
The suffering of Jesus the world greatest suffering

Scourging or Flogging was far worse than whipping. Jesus was bend over a post so he couldn't kneel down and he couldn't stand up either.

He hands tie to the post and strip him down to the waist and then two men would hold these whips that had a cat of nine tails in it - Nine lone strands of leather. In each of these strands of leather they would tie two things - sharp hone in order to cut the skin, and bits of lead in order to bruise the skin. They would whip and when they would whip it would not only cut the back open but also bruise it at the same time. Jesus back was one bloody pulp even before He went to the cross. When you figure 39 times nine that's how many scars Jesus had on His bike even before He went to the cross.

The Death of Jesus the world greatest Death.
Making Calvary the world greatest event.
The Blood that Jesus shed at Calvary the World Greatest Chemical Fluid.
The Resurrection of Jesus the World Greatest Miracle.
1 Cor 15:14 - and if Christ hath not been raised, then is our preaching vain, your faith also is vain.
1 Cor 15:17 - and if Christ hath not been raised, your faith is vain; ye are yet in your sins
That makes the Gospel the World's greatest Message.
The Second birth the greatest Experience
Holiness the world greatest Lifestyle

Bishop Gregory Tucker

Prayer the World greatest Power
Praise the World greatest Expression
Worship the World greatest Occupation
The coming of Jesus the World greatest Expectation
Apostolic Doctrine the World greatest Truth

We serve the World Greatest Saviour: God Not Dead He's Yet Alive
The Greatest Mistake ever made was when those soldiers put the cross in the Ground and lifted Jesus up.
John 12:32 - And I, if I be lifted up from the earth, will draw all men unto myself. When we lift up Jesus by giving Him Praise & Honor.
Singing about Him and Praying to Him and thanking Him for who he is.
Psalms 34:1-4
I will bless the Lord at all times:
His praise shall continually be in my mouth.
My soul shall make her boast in the Lord:
the humble shall hear thereof, and be glad.
O magnify the Lord with me,
and let us exalt his name together.
I sought the Lord, and he heard me,
and delivered me from all my fears

Psalms 22:3 - But thou art holy, O thou that inhabitest the praises of Israel

(The Secret of our future lies in our daily routine)
If you read the Bible you will be smart
If you study the Bible you will be wise
If you believe the Bible you will be safe
If you obey the Bible you will be Holy

Don't forget about God
If you want know God know the father
If you want to see God see Jesus
If you want to feel God receive the Holy Spirit
Can you say The Jesus is your Father the Lord Prayer says
Our Father which art in Heaven Hallowed be thy name. (Worship)

Can you say that God is your Father if you haven't confess him, repented of your sins been baptized and filled with Him Spirit can you say honestly that God if your father.

If you let him into your life he will be your Counselor, Defense attorney, Refuge, Master.

REFERENCE NOTES

Chapter 1: Bob Yandian – Ephesians – Our Blueprint for Maturity

Chapter 2: (Book) Jentezen Franklin – Believe that you can

Chapter 8: Song by Erica Campbell – All I need is a little more Jesus

Chapter 10: Song by Sam Cooke – It been a long time coming

Chapter 18: (Book) Dr. David Yonggi Cho - Fourth Dimensional Living in a three dimension world

Chapter 28: (Book) Swedenborg Emanuel - Heaven and its wonders & Hell

Chapter 29: Song The Gambler by Kenny Rogers

Chapter 30: Song I won't complain by Rev Paul Jones

Chapter 37: (Book) Why Bad Grades Happen to Good Teachers by Linda & Alvin Silbert

www.ingramcontent.com/pod-product-compliance
Lightning Source LLC
Chambersburg PA
CBHW030817180526
45163CB00003B/1315